101 TEXTURES
IN OIL & ACRYLIC

PRACTICAL TECHNIQUES FOR RENDERING A VARIETY OF SURFACES

MIA TAVONATTI

Brimming with creative inspiration, how-to projects, and useful information to enrich your everyday life, Quarto Knows is a favorite destination for those pursuing their interests and passions. Visit our site and dig deeper with our books into your area of interest: Quarto Creates, Quarto Cooks, Quarto Homes, Quarto Lives, Quarto Drives, Quarto Explores, Quarto Gifts, or Quarto Kids.

First Published in 2013 by Walter Foster Publishing, an imprint of The Quarto Group. 6 Orchard Road, Suite 100, Lake Forest, CA 92630, USA. **T** (949) 380-7510 **F** (949) 380-7575 **www.QuartoKnows.com**

Walter Foster Publishing titles are also available at discount for retail, wholesale, promotional, and bulk purchase. For details, contact the Special Sales Manager by email at specialsales@quarto.com or by mail at The Quarto Group, Attn: Special Sales Manager, 401 Second Avenue North, Suite 310, Minneapolis, MN 55401 USA.

ISBN: 978-1-63322-686-9

Digital edition published in 2019
eISBN: 978-1-63322-687-6

Printed in China
10 9 8 7 6 5 4 3 2 1

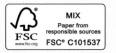

Table of Contents

■ **Getting Started** **4**
How to Use This Book 5
Tools & Materials 6
Color Theory11
Painting Techniques12

■ **People****16**
1. Smooth Skin17
2. Aged Skin18
3. Straight Hair19
4. Curly Hair20
5. Wavy Hair21
6. Facial Hair22
7. Eye .23

■ **Animals & Insects** **24**
8. Smooth Canine Fur25
9. Curly Canine Fur26
10. Coarse Canine Fur27
11. Long Cat Hair28
12. Short Cat Hair29
13. Horse Coat30
14. Horse Mane31
15. Dolphin32
16. Elephant33
17. Snake .34
18. Leopard35
19. Zebra .36
20. Starfish37
21. Feathers38
22. Butterfly Wing39
23. Spiderweb40

■ **Fabrics & Textiles** **42**
24. Burlap .43
25. Wool .44
26. Tweed .45
27. Plaid .46
28. Denim .47
29. Cotton .48
30. Silk .49
31. Satin .50
32. Velvet .51
33. Leather52
34. Patent Leather53
35. Sequins54
36. Lace .55
37. Straw Hat56
38. Woven Basket57

■ **Glass, Stone, Ceramics, Wood & Metal58**
39. Beveled Crystal59
40. Clear Glass60
41. Amber-Colored Glass61
42. Cobalt-Colored Glass62
43. Porcelain63
44. Shiny Gold64
45. Polished Sterling Silver65
46. Pewter .66
47. Copper .67
48. Hammered Brass68

49. Clay Pottery69
50. Rusted Steel70
51. Smooth Concrete71
52. Stucco .72
53. Brick .73
54. Cobblestone74
55. Marble .75
56. Pearl .76
57. Diamond77
58. Smooth Wood78
59. Aged Wood79
60. Wooden Barrel80
61. Wrought iron81

■ **Food & Beverage** **82**
62. Citrus Fruit Rind83
63. Orange Fruit84
64. Apple .85
65. Grapes86
66. Coconut87
67. Peanut Shell88
68. Walnut Shell89
69. White Wine90
70. Red Wine91
71. Black Coffee82
72. French Baguette93
73. Frosting94
74. Dark Chocolate95

■ **Nature****96**
75. Tree Bark97
76. Pine Tree Needles98
77. Pinecone99
78. Palm Frond100
79. Thatched Roof101
80. Fern .102
81. Moss .103
82. Grass Field104
83. Flower Petals105
84. Mountain Rock106
85. Smooth Rock107
86. River Pebbles108
87. Sand .109
88. Seashell110
89. Running River111
90. Still Lake112
91. Rippled Lake113
92. Bubbles114
93. Smoke115
94. Ocean116
95. Clouds117
96. Rain Drops on a Window118
97. Rain Drops from the Sky119
98. Snowflakes120
99. Snow Powder121
100. Frozen Pond122
101. Fall Foliage123

Artist's Gallery **124**
About the Author **128**

GETTING STARTED

How to Use This Book

This book includes step-by-step instructions for achieving a wide range of textures with oil or acrylic. To use this book most effectively, follow the six steps below.

1. GATHER the tools and materials you need to start painting. (See pages 6–10.)

2. LEARN the painting techniques on pages 12–15. Acquainting yourself with the vocabulary and methods for applying paint will help you quickly and easily understand the instructions for replicating each texture.

3. LOCATE your desired texture in the Table of Contents on page 3. The textures are organized in five categories:

| People | Animals & Insects | Fabrics & Textiles |

| Glass, Stone, Ceramics, Wood & Metal | Food & Beverage | Nature |

4. BEGIN with a basic drawing, as has been done with most of the textures in the book. A drawing also provides a guideline for applying the paint in later steps.

5. FOLLOW the step-by-step process outlined on the page to paint your texture.

6. PRACTICE the texture as it appears in the book; then integrate the texture into your own painting. Refer to the general process, values, and strokes in the instructions, adjusting the colors to fit the color palette of your painting.

Tools & Materials

Sketch Pads

Some of the textures demonstrated in this book start with a basic sketch; however before putting paint to canvas, it's best to work out your textures on paper. Sketch pads are ideal for this purpose. They come in all shapes and sizes, and they are easy to carry. Whenever you see an interesting texture that you'd like to paint, draw a quick sketch. Then use your sketch as a reference to draw the texture directly on your support, or transfer it using tracing or transfer paper.

Tracing and Transfer Paper

Tracing and transfer paper are used to transfer the outlines of a work to a support. Transfer paper is coated on one side with graphite (similar to carbon paper). Simply place the transfer paper face down on your support; then place the artwork you wish to transfer face up on the transfer paper. Use a pencil to trace over the lines of the artwork, pressing firmly. The outlines will transfer to your support. To use tracing paper, coat one side of the tracing paper with graphite and follow the same process.

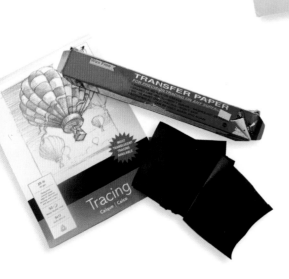

Drawing Pencils

Artist's pencils contain a graphite center and are sorted by hardness, or grade, from very soft (9B) to very hard (9H). Pencil grade is not standardized, so it's best to have a set of pencils from the same brand for consistency.

- Very hard: 5H–9H
- Hard: 3H–4H
- Medium hard: H–2H
- Medium: HB-F
- Medium soft: B–2B
- Soft: 3B–4B
- Very soft: 5B–9B

Paintbrushes

Paintbrushes are classified by hair type (soft or stiff and natural or synthetic), style (flat, filbert, and round), and size. Flat brushes are great for producing straight, sharp edges. Medium and large flats are good for quickly filling in large areas. Small round and small filbert brushes have pointed tips that are suitable for adding details, and larger rounds and filberts are perfect for sketching rough outlines and general painting. When purchasing round or pointed brushes, I opt for those with particularly long hairs or bristles.

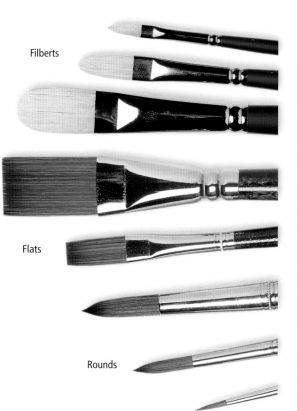

Filberts

Flats

Rounds

The following brushes were used for the projects in this book:

- 1/8-inch, 1/4-inch, 1/2-inch, 3/4-inch, and 1-inch flat brushes
- #1 round, #2 round, #3 round, #4 round, and #6 round brushes
- 1-inch #2 striper brush

HAKE BRUSH A hake brush is handy for blending large areas. While the area is still wet, use a clean, dry hake to lightly stroke back and forth over the color. Be sure to remove any stray hairs before the paint dries and never clean your hake in thinner until you're done painting, as it will take a long time to dry.

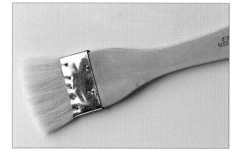

CLEANING BRUSHES A jar that contains a coil will save time and mess because it will loosen the paint from the brush. For removing oil paint, you need to use turpentine. Once the paint has been removed, you can use brush soap and warm water—never hot—to remove any residual paint. When painting with acrylic, use soap and water to remove paint from the brush. Reshape the bristles and lay flat to dry. Never store brushes bristle-side down.

Selecting Paints

There are different grades of oil and acrylic paint, including "student grade" and "artist grade." Artist-grade paints are a little more expensive, but they contain better-quality pigment and fewer additives. The colors are also more vibrant and will stay true longer than student-grade paints.

Painting and Palette Knives

Palette knives can be used to mix paint on your palette or as a tool for applying paint to your support. Painting knives usually have a smaller, diamond-shaped head; palette (mixing) knives usually have a longer, more rectangular blade. Some knives have raised handles, which help prevent you from getting paint on your hand as you work.

Mixing Palettes

Whatever type of mixing palette you choose—glass, wood, plastic, or paper—make sure it's easy to clean and large enough for mixing your colors. You can purchase an airtight plastic box to keep your leftover paint fresh between sessions.

Varnishes

Varnishes are used to protect your painting—spray-on varnish temporarily sets the paint, and brush-on varnish permanently protects your work.

Supports

The surface on which you paint is called the support. Ready-made canvases are available in a variety of sizes and come pre-primed and either stretched on a frame or glued over a board. Watercolor illustration boards work well with acrylic paint, providing a smoother surface. When working with oil paint, artists generally use canvas or wood. When using wood or any other porous material, you may need to prime the surface first to keep the paint from soaking through.

PREPARING YOUR OWN SUPPORT

It's economical and easy to prime your own supports. Gesso—a polymer product with the same base ingredients as acrylic paint—is a great coating material because it primes and seals at once. It's also fast-drying and is available at any art supply store. Gesso is usually white, but it is also available in other colors. Apply gesso directly to your support with a brush; a palette knife; a spatula; or any large, flat application tool.

Additional Supplies

Paper towels and lint-free cotton rags are invaluable for cleaning your tools and brushes. They can also be used as painting tools to scrub in washes or soften edges. In addition, you may want to use a mahlstick to help you steady your hand when working on a large support. Silk sea sponges, old toothbrushes, drawing stumps, and cotton swabs are also useful for rendering special effects.

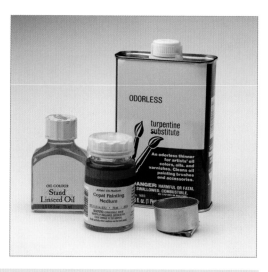

Mediums and Additives

There are a variety of oil and acrylic mediums available that achieve a wide range of effects. Mediums and thinners are used to modify a paint's consistency. There are different types of oil painting mediums available—some act as thinners (linseed oil); others speed up drying time (copal). Acrylic paint dries quickly, so it's helpful to keep a spray bottle filled with water nearby. I thin my acrylics with water, but I thin my oils with a mix of one part linseed oil to two parts turpentine or mineral spirits, which I refer to as "medium" throughout this book.

ACRYLIC MEDIUMS Water is not the only substance that you can add to your acrylic paint to alter its consistency. There are a variety of acrylic mediums you can use to achieve various effects—from thin, glossy layers to thick, impasto strokes. Gloss medium is a runny fluid that is useful for thinning the paint while maintaining its luster. In contrast, matte medium causes the paint to dry to a soft satin sheen. (Satin medium—not pictured—produces a similar effect.) Gel medium has more body than gloss or matte mediums, giving the paint a heavier consistency for thick strokes. Texture mediums are even thicker, and they turn the paint into a paste; they come in different types, such as sand and fiber. Retarding medium helps slow the drying time of the paints. And flow improver increases the fluidity of paint and eliminates brush marks within strokes. Although these mediums may at first appear milky or opaque, most dry clear or almost clear.

Gloss medium

Matte medium

Gel medium

Texture medium

Retarding medium

Flow improver

Color Theory

All colors are derived from the three primary colors—yellow, red, and blue. The secondary colors—purple, green, and orange—are each a combination of two primaries, whereas tertiary colors are mixtures of a primary and a secondary (red-orange and blue-green). Complementary colors are any two colors directly across from each other on the color wheel. When placed next to each other, complementary colors create visual interest, but when mixed, they neutralize (or gray) one another. Analogous colors are any three adjacent colors on the color wheel.

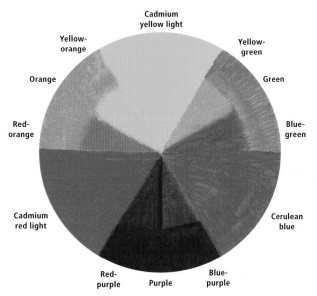

Mixing Color

Successfully mixing colors is a learned skill—the more you practice, the better you will become. One of the most important things is to train your eye to see the shapes of color in an object—the varying hues, values, tints, tones, and shades. Once you can see them, you can practice mixing them. Additionally, your ability to discern the variations in color under different lighting conditions is one of the keys to successful color mixing. The chart at right shows a small portion of colors that can be created from a basic palette.

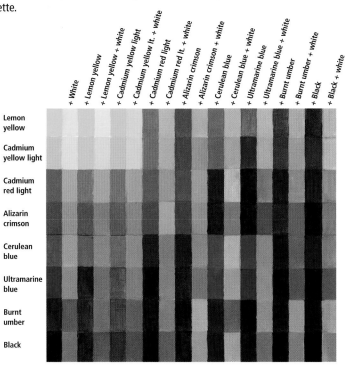

Painting Techniques

PAINTING THICKLY Load your brush or knife with thick, opaque paint and apply it liberally to create texture.

THINNING PAINT Dilute your color with water (if using acrylic) or medium (if using oil) to create transparent layers of paint.

DRYBRUSH Load a brush, wipe off excess paint, and lightly drag it over the surface to create irregular effects.

SCUMBLING Lightly brush semi-opaque color over dry paint, so the underlying colors show through.

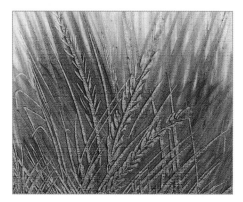

SCRAPE Use the tip of a palette knife to scrape color away. This can create an interesting texture or represent grasses.

LIFTING OUT For subtle highlights, wipe paint off with a paper towel or blot it with a tissue. To lighten the color or fix mistakes, use a moistened rag (use thinner with oil paint).

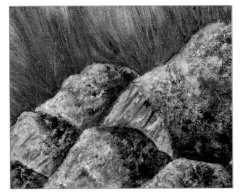

SPONGING Apply paint with a natural sponge to create mottled textures for subjects such as rocks, trees, or foliage.

STIPPLING For highlights, use a stiff-bristle brush and hold it straight, bristle-side down. Dab on color quickly, creating a series of dots.

BLENDING Lay in the base colors, and lightly stroke the brush back and forth to pull the colors together.

WIPING AWAY To create subtle highlights or simply remove paint from canvas, wipe away the paint using a paper towel, tissue, or soft cloth.

WET-INTO-WET Apply color next to another color that is still wet. Blend the two by lightly stroking over the area where they meet. Use your brush to soften the edge, producing a smooth transition.

SPATTERING To spatter, load a brush—or toothbrush—with paint and tap your finger against the handle. The splattered paint creates the appearance of rocks or sand.

Glazing

Glazes are thin mixes of paint and water or medium applied over a layer of existing dry color. An important technique in painting, glazing can be used to darken or alter colors in a painting. Glazes are transparent, so the previous color shows through to create rich blends. They can be used to accent or mute the base color or alter the perceived color temperature of the painting. When you start glazing with acrylic, create a mix of about 15 parts water and 1 part paint. When working with oil, use equal parts paint and turpentine to start. Add more turpentine as needed until the paint is the consistency you desire. It's better to begin with glazes that are weak than ones that are overpowering, as you can always add more glazes after the paint dries. Occasionally, I use *semi-glazes*, which are more opaque and slightly thicker than traditional glazes.

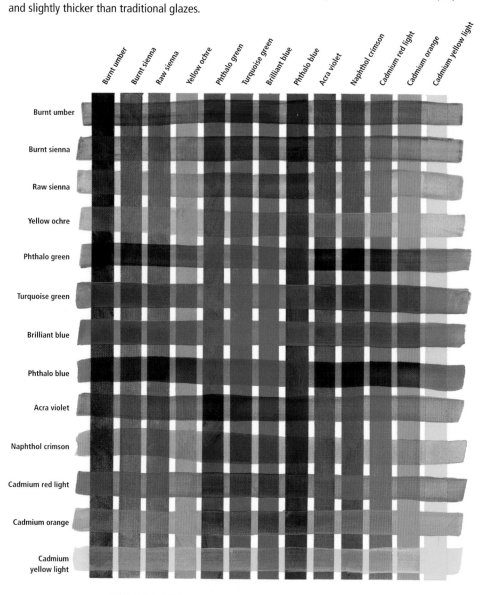

GLAZING GRID In this chart, transparent glazes of 13 different colors are layered over opaque strokes of the same colors. Notice how the vertical opaque strokes are altered by the horizontal translucent strokes.

Applying an Underpainting

An underpainting is a thin wash of color applied to the support at the beginning of the painting process. An underpainting can be used to tone the support to help maintain a desired temperature in a final painting. For example, a burnt sienna wash would establish a warm base for your painting; a blue wash would create a cool base. An underpainting can also provide a base color that will "marry with" subsequent colors to create a unified color scheme. You can also use an underpainting to create a visual color and value "map," giving you a guideline for applying future layers. An underpainting can help provide harmony and depth in your paintings. Experiment with various underpaintings to discover which colors you prefer.

Magenta

Burnt sienna

Purple

Phthalo violet

Pounce Technique

The pounce technique is an easy way to eliminate visible brushstrokes to achieve smooth, even areas of color. To begin, cut a 12- x 12-inch or larger square of soft cotton cloth (such as jersey or T-shirt material). Ball up the cloth by folding back the edges to create a creaseless round pad. Use this pad to dab at an area of color on your canvas. For best results, work in an up-and-down motion and avoid smearing paint to the side.

Impasto Strokes

Impasto strokes are thickly applied brushstrokes that add dimension and textural variation to your work. You can apply impasto strokes with a heavily loaded brush, or you can apply them with painting knives. To use a painting knife, scoop up your paint with the flat blade and spread a thick layer of paint over the surface. The resulting texture is great for mimicking rough elements, like stone walls or rocky landscapes.

PEOPLE

COLOR PALETTE

• alizarin crimson • burnt sienna
• cadmium yellow medium • ivory black • Payne's gray
• phthalo blue • purple lake • raw sienna • sap green
• titanium white • ultramarine blue • yellow ochre

Smooth Skin

1

STEP ONE Soft skin has a fine texture with smooth gradations of warm and cool tones. Create a mix of two parts burnt sienna to one part sap green, and thin it down on your palette. (See "Thinning Paint," page 12.) Cover your drawing with this transparent mixture using a ½-inch flat brush, spreading the color smoothly. Use the pounce technique to remove all brushmarks, leaving as smooth a surface as possible. (See "Pounce Technique," page 15.) Finally, roll a small piece of soft cloth to make a point and wipe off paint from the lightest areas of the image, such as the background and neck. (See "Wiping Away," page 13.)

STEP TWO Mix equal parts of burnt sienna, black, and white to create a cool skin tone. Using a ¼-inch flat brush, paint the shadow and middle-value areas of the back, under the chin, and over the back of the neck with short, impressionistic strokes to simulate the texture of skin. To lighten and warm the color, slowly add more white and reduce the black for the lighter areas of the skin.

STEP THREE To add subtle texture and build up the middle values, use a ½-inch flat brush to apply mixes of burnt sienna and white. Wipe off the excess paint from your brush onto a cotton rag before laying on short, impressionistic drybrush marks that give the impression of skin texture. Next lay a painterly layer of white in the background areas, and use a fine, soft, dry brush to trace the lines of the front and back of the neck. This will soften and blur the edges to create more depth.

STEP FOUR Continue to work from dark to light using short, impressionistic strokes. Slowly build up the light layer by layer with a simple mix of burnt sienna and white. The lightest area will eventually have the thickest paint, which is a traditional way to build depth in a painting. For the lightest skin tones, cool the mix with a touch of phthalo blue to complement the warm shadows.

2 Aged Skin

STEP ONE Aged skin features deep wrinkle lines with strong contrast between the lights and shadows. To capture this, create a mix of one part burnt sienna to two parts sap green, and thin it down on your palette. Use a ½-inch flat brush to cover your drawing with this transparent mixture, and use the pounce technique to thin out your color until you can see your drawing through the paint. Next, using an old ¼-inch flat brush that has splayed out slightly from use, dab the end of the brush into the same paint mixture and then dab it into the shadow areas of your drawing, leaving a stippled texture that resembles pores in skin. (See "Stippling," page 13.)

STEP TWO Mix burnt sienna with a small amount of black to create a dark skin tone. With a small round brush, paint the darkest areas, including the deepest parts of the wrinkles, the shadows under the nose, and where the nose and cheek meet. Trace over the wrinkle lines with a clean brush to soften the lines and blend the color out into the softer shadow areas, such as the dimple on the nose.

STEP THREE To begin building the middle values of this rough, wrinkled skin, mix equal parts of purple lake and raw sienna and varying amounts of white to lighten. Working with a value very close to your darkest shadow color, slowly dab in spots of color, working from the shadows into the light. Both a ¼-inch flat brush and a small pointed brush would work well, depending on the size of the area you are working on. Do not blend the colors together on the painting, but rather leave separate marks, which add to the detail in the wrinkles and pores.

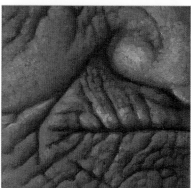

STEP FOUR In this final layer, focus on bringing up the light that is hitting the nose, cheek, and lips, in addition to the light edges of the wrinkles. Using a very neutral, cool skin tone mixed with purple lake, burnt sienna, and white, continue to work from the previous middle value toward the lightest highlights using a ¼-inch flat brush. Wipe most of the excess paint off your brush onto a cloth. Use the flat edge for larger strokes and the corners for tiny areas, using the drybrush technique to pull out the texture of the canvas or board to mimic the roughness of aged skin. (See "Drybrush," page 12.)

3 Straight Hair

STEP ONE To create long, flowing red hair, start with equal parts of burnt sienna and sap green to create a warm, golden, transparent brown for the middle to dark values of the hair. Rotate a ½-inch flat brush to use the long, thin edge rather than the wide, flat edge, and paint long, smooth strokes from top to bottom in the direction of the hair. Capture smooth curves to give the hair a sense of movement.

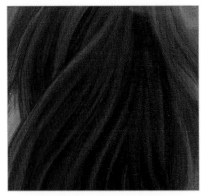

STEP TWO Next paint the deep shadows with a mix of equal parts of black and burnt sienna, using the thin edge of the same ½-inch brush and long strokes from the top to the bottom. Use pure burnt sienna to paint in the middle-value areas of the hair to achieve a warm, rich red tone. Go over your lines as many times as needed to create smooth, silky lines.

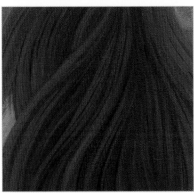

STEP THREE Continue building the middle and lighter strands of red hair using a long, fine-pointed brush loaded with a mix of burnt sienna, cadmium yellow medium, and white. Turn the painting in the direction that makes it easiest for you to create long, sweeping lines. If needed, thin down your paint for a smoother flow. Then use a darker mix of equal parts of burnt sienna and ultramarine blue to redefine the shadow areas and further smooth the lines. Reshape where needed.

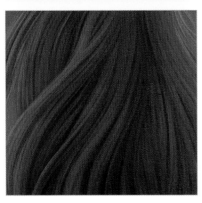

STEP FOUR This final layer is all about bringing up the values in the areas where the light is strongest, such as the sides of the head. For the lightest strands of hair along the sides, use one part white, two parts cadmium yellow medium, and one or two parts burnt sienna to retain the reddish orange color. For the cooler reflective lights on the back, mix equal parts of alizarin crimson and burnt sienna with a touch of white to lighten or ultramarine blue to cool. Turn your painting to the angle that is most comfortable and allows for the smoothest strokes with a long, pointed #2 brush. Thin your paint to create smooth, fine lines that flow easily.

4 Curly Hair

STEP ONE To create these big "dirty" blonde curls, mix equal parts of burnt sienna and sap green to create a warm, golden, transparent brown. This will be the middle value of the hair. Use a ½-inch flat brush to cover your drawing with this transparent mixture; then use the pounce technique to thin the color until you can see your drawing through the paint. Finally, using your eraser cloth, remove some color from areas of the curls where the light is strongest.

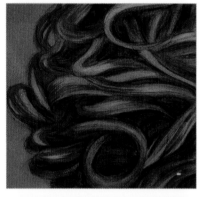

STEP TWO Using a ¼-inch brush and equal parts of black and burnt sienna, paint the darkest shadow areas and curls, sweeping your brush in the same direction as the hair. A stiffer brush will create harder, more wiry hair, where as a longer, softer brush will result in silkier strands. After you have achieved the values you desire, you can soften the brushmarks by cleaning your brush, wiping it almost dry, and retracing your strokes as many times as necessary. As the curls recede into the shadows, your edges should be soft to create more realistic depth.

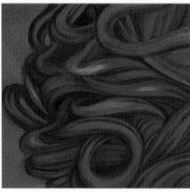

STEP THREE Continue to build the middle values using a fine-pointed brush (longer bristles work better for hair) and varying blends of ultramarine blue, burnt sienna, and white. If some of the curls get over-painted, simply use a darker mixture to redefine your shadows and darken the ends of the curls where they move in and out of the shadows. Do not focus on single strands of hair in this stage; rather, keep your edges soft to create a more general impression of curls.

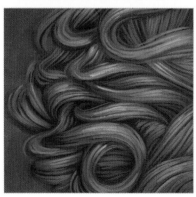

STEP FOUR Highlights on curls tend to be much more dramatic and brighter than on straight hair because the light is concentrated on a smaller section of the curl. Use various blends of yellow ochre and white to add detail to the curls, working along the tops of the curls and toward the ends in shadow. Use a very light touch and thin paint to create finer lines and bring the individual hairs into focus. Using more and more white and a touch of phthalo blue to cool down your highlights, hit the brightest highlights with thicker paint using a fine-pointed #2 brush.

5 Wavy Hair

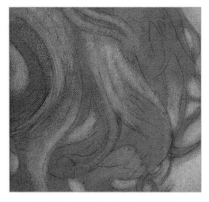

STEP ONE Wavy hair requires a combination of the techniques for straight and curly hair. Mix one-third burnt sienna with two-thirds sap green to create a warm, golden, transparent brown for the middle-to-dark values of the hair. Using a ½-inch brush, cover your drawing with this transparent color mixture and, using the pounce technique, thin the color until you can see your drawing through the paint. Finally, using your eraser cloth, remove some of the color from the areas where the light hits the waves most and from the negative spaces around the edges of the hair. This leaves soft edges for the remaining color, which helps them recede and suggest more depth within the mass of hair.

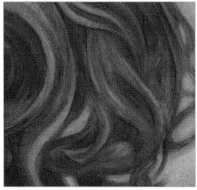

STEP TWO For the shadow areas, mix equal parts of raw sienna and black. A ¼-inch flat brush and long, sweeping strokes work well to create smoothness while giving you enough control for the smaller negative spaces between the waves and at the ends of loose strands around the edges.

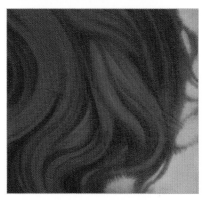

STEP THREE Build the middle and light brown values using varying blends of burnt sienna and cadmium yellow medium and full-length strokes with a long, fine-pointed brush. Curl your wrist as you follow your lines around the waves. Retrace your strokes as many times as needed to attain the smoothness you desire. Thin your paint to create silkier lines, but not so much that it becomes transparent. Redefine your shapes and shadows with a dark mix of sap green and burnt sienna; then blur the edges of the hair, always stroking in the direction of the hair. To paint the negative spaces between the loose strands of hair, dab white and a little green gold hue between the hair. Using a very soft, dry fan brush, lightly brush the white toward the hair to soften the edges.

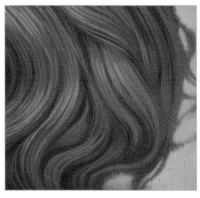

STEP FOUR Spend some time building up the middle values using a long pointed brush with very soft, long strokes. Each stroke should start with a point (less pressure) and widen (more pressure) as you reach the center of the wave. Use less pressure again as you near the shadow end of the wave. Thin down your paint and turn the painting to the angle that allows the most fluidity in your movement to produce longer, smoother, and softer strokes. For the highlights, use equal parts of raw sienna and white.

6 Facial Hair

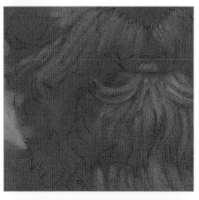

STEP ONE Mix two parts burnt sienna to one part sap green, and thin the paint on your palette. Using a ½-inch flat brush, cover your drawing with this transparent color mixture, spreading the color as smoothly as possible. Use the pounce technique to remove all brushmarks. Next use your eraser cloth to remove some of the color from the areas where the light hits the moustache and beard, or where there is more gray hair.

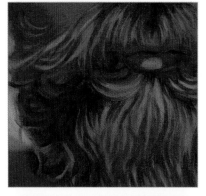

STEP TWO Create the darkest shadow areas, including under the lips and nose and between the moustache and beard, with the thin edge of a ¼-inch flat brush and a mixture of equal parts of burnt sienna and black. By adding a small amount of alizarin crimson and white to lighten, you can create a dark pink lip color that still integrates with the beard and other skin tones.

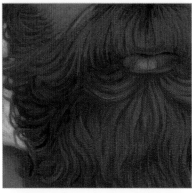

STEP THREE Fill in the middle value of this red beard and moustache using a fine-pointed brush and a thinned mix of equal parts of raw sienna and burnt sienna. With burnt sienna and sap green, redefine your shadows and soften edges where needed. For the cheek, lighten burnt sienna with varying amounts of white and use your small pointed brush to create fine, impressionistic strokes that disappear as they merge with the beard along the hairline.

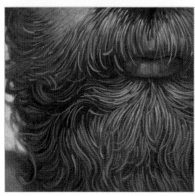

STEP FOUR Start by adding lighter whiskers on the cheek and lower parts of the beard with a fine-pointed brush and variations of raw sienna, burnt sienna, and white. To capture the variation of hair growth in longer, untrimmed beards and moustaches, paint in short strands against the direction of the main hair growth, especially in the shadow areas and over the lips. Finally, add the lightest strands, starting at the end of the hair and stroking back toward the follicle for a thick-to-thin line, creating the illusion that it is disappearing into the beard.

Eye

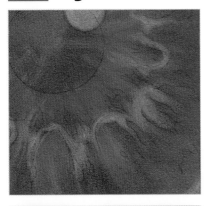

STEP ONE The iris of the eye has intricate detail and soft, stringy areas that can be treated almost like hair at the beginning. There is so much depth and color variation, but the edges of these areas need to be kept defined yet soft to retain the watery effect in the eye. Start by laying a smooth layer of two parts burnt sienna mixed with one part sap green using your soft ½-inch flat brush. Use the pounce technique to smooth out the brushstrokes and follow up with the eraser cloth, removing color along the light edges of the gold area that flares out from the pupil. Do the same with the circular highlight, as it is difficult to achieve a bright white over dark color.

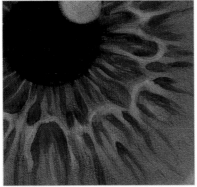

STEP TWO The pupil comes to life with a simple mix of black warmed up with burnt sienna. After painting in this area with your ¼-inch flat brush, use the same brush to drag this color outward in loose, squiggly lines that radiate from the center of the pupil. This will soften the edge of the circle and begin to establish the warm brownish areas of the iris pattern. With a small pointed brush and a lighter mix of equal parts of black and burnt sienna, paint the remaining dark parts of the iris using loose, painterly lines with soft edges. You can wipe off your brush and trace over your strokes to soften edges and make the eye appear smooth and moist.

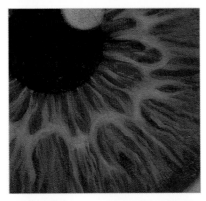

STEP THREE To introduce the blue tones in the iris, use a long, fine-pointed brush and various blends of white with Payne's gray for a more neutral color, or ultramarine blue for brighter eyes. Thin this color so your marks flow smoothly to retain a blurred, watery affect. Working from the center outward toward the edges of the iris, create loose, squiggly lines in varying opacities to replicate the complex patterns and depth of the iris.

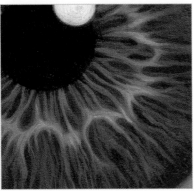

STEP FOUR For the final touches on the iris, fill in the white of the circular highlight with a #3 round brush. Then punch up the color on the golden rays fanning out from the pupil using a #1 or #2 round brush and a mixture of yellow ochre, burnt sienna, and white.

ANIMALS & INSECTS

COLOR PALETTE

- alizarin crimson • burnt sienna • burnt umber
- cadmium orange • cadmium red light
- cadmium yellow light • cadmium yellow medium
- cobalt blue • green gold hue • ivory black
- Payne's gray • phthalo blue • purple lake
- raw sienna • sap green
- titanium white • Venetian red • yellow ochre

8 Smooth Canine Fur

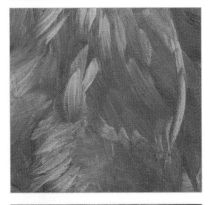

STEP ONE To create long, smooth canine fur like that of a golden retriever, begin by laying in a medium value of thinned burnt sienna and sap green using a ½-inch flat brush. This golden brown mix will show through the fur as you paint subsequent layers, but it is also transparent and will allow the drawing to show through. Remove some of the color in the lightest areas by cleaning your medium pointed brush, wiping it almost dry, and picking out color wherever you desire.

STEP TWO To build a good base from which to render the soft, light fur, continue to darken the shadows with equal parts of raw sienna and black using a soft ½-inch flat brush. Always work your strokes in the direction of the hair growth. For the background, add some white to create a warm gray and work from the edges of your piece toward the fur, lessening your pressure at the end of each stroke to create soft, blurred ends. Add more white to this mixture and use a long, fine-pointed brush to paint loose, soft-edged hairs that fade into the background, working wet-into-wet. (See "Wet-into-Wet," page 13.)

STEP THREE To build the middle tones of the smooth, soft hair, start by mixing cadmium yellow medium, yellow ochre, and a bit of black. Using a fine-pointed brush, twist and turn your wrist as you move in the direction of the hair growth, creating brushmarks that range from one to two inches long. Vary the pressure you put on the brush to create lines that are both thick and thin. For the lighter areas of the fur, add a small amount of white. You may go over your brushmarks with a soft, dry brush to minimize the texture and create the illusion of softer fur.

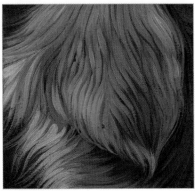

STEP FOUR To create the final layer of smooth canine fur, mix three parts of raw sienna with one part white and one part cadmium yellow medium. This creates a color that's just a couple steps lighter than those you already used as a base. Load your pointed brush and wipe off the excess paint onto a dry cloth so your brushmarks are softer and silkier. Start with the bottom layers of fur and work upward so each brushstroke lays over the previous. Use various amounts of pressure to create thicker and thinner lines. It is a good idea to thin the paint for better flow. Add a very small amount of black to this mixture to create a greenish tone for the shadow areas, but be careful to leave these areas simpler and softer so they recede. Add more white to your original mixture for the lighter areas.

9 Curly Canine Fur

STEP ONE The easiest way to capture the depth and shapes of curly canine fur is to work from dark to light, beginning with a base of the darkest shadows. Create a thin mix of four parts burnt sienna to one part black; then use a ½-inch flat brush to lay in a flat area of color. Then use the pounce technique to smooth out the brushmarks. To remove some color from the lightest areas of fur, use a cotton swab dipped in mineral spirits (if using oil) or water (if using acrylic) to gently wipe away the paint.

STEP TWO To assist in creating the soft edges found in curly or fuzzy hair, start by painting a thin layer of medium (if using oil) or water (if using acrylic) directly over the dried underpainting. When you paint over this wet surface, your brushmarks will be less dramatic and blurred. For the shadows, create a mix of equal parts of black and burnt sienna. Then use a pointed brush to dab the color into the spaces between the curls and under the ear, using squiggly marks. You can blend this more by lightly sweeping a soft, dry fan brush over your marks to knock down the texture. Allow the paint to dry.

STEP THREE To create softer brushstrokes, begin by wetting your entire painting again. Next mix equal parts of yellow ochre, burnt sienna, and black for the middle values of this curly fur. Using a ¼-inch flat brush, begin to build the lighter values with random, squiggly lines that vary in thickness, moving from top to bottom. To soften the brushmarks, use a fine-pointed brush with a darker version of burnt sienna mixed with black to repaint some of your shadows, blending them with the wet paint in the curls.

STEP FOUR For the last layers of this curly dog hair, mix equal parts of raw sienna and white. Using the corner of a ¼-inch flat brush, gently and loosely build up the lighter areas of the hair. Build your values from dark to light slowly to create a softer effect. Switch to a smaller pointed brush if you desire more control, but hold it very loosely, allowing the brush to do the work for you. You will achieve more natural variation in your marks. Remember that your brush is not a pencil, and you are not drawing. Now is your chance to get loose. Add a small amount of cadmium red light to warm the fur or white to lighten it. Use burnt sienna to darken the mix for detail in the shadow areas.

10 Coarse Canine Fur

STEP ONE To save time in creating the look of short, coarse fur, start by painting your darkest shadow color using a mix of three parts burnt sienna to one part black. Thin the color until it is soft and smooth but not watery. Apply the wash with a ½-inch flat brush and use the pounce technique to eliminate your brushmarks. Start to define the fur texture along the edges by lifting color in short strokes in the lightest areas using a dry, fine-pointed brush.

STEP TWO Short, choppy strokes with the edge of a ½-inch flat brush work well for capturing the texture of coarse hair. Always work in the direction of the hair growth and allow some of the underpainting to show through to start building depth and detail with minimal effort. Use a darker version of your mix of black and burnt sienna.

STEP THREE To create the illusion of coarse, scratchy fur, try painting with a pointed palette knife instead of a brush. Mix equal parts of yellow ochre, cadmium red light, and cadmium yellow medium for the middle values of the fur. Use the palette knife point and its edge to lay in the color. Scratch into the paint with the tip of the palette knife to spread the color in the direction of the hair growth and create the illusion of fine hairs. (See "Scraping," page 12.)

STEP FOUR There should be a lot of texture on your painting from the palette work in step three, so this is a good time to use the drybrush technique. Put a very small amount of paint on your ½-inch flat brush. Wipe off the excess paint on your rag. Then, with your brush on its side, stroke lightly across the texture marks so you only pick up the raised parts. Don't push the paint into the grooves. After you've exposed as much texture as you can, use your palette knife to build up even more texture in the light areas. Blend these new areas into the previous ones by scratching into them with the pointed end of your palette knife, working the paint in the direction of the hair growth.

11 Long Cat Hair

STEP ONE Start colorful fur for a longhair cat simply by establishing a warm undertone that provides depth and contrast under the cooler gray and white of the longer hairs. Use a thin mixture of two parts raw sienna to one part black and a ½-inch flat brush to paint long, smooth strokes in the direction of fur growth. Clean your brush and pull up some of this color along the lighter areas. This will make it easier to build up your white later.

STEP TWO Using a mix of two parts black to one part raw sienna, start to define the fur by building up the shadows between the individual sections. Use long, thin strokes with a small pointed brush, and vary your pressure or spin the brush slightly in your hand to create thicker and thinner lines that add variation and a sense of realism.

STEP THREE Now create the warm white and gray tones in the fur with various mixtures of black, white, and yellow ochre. Continue using the long strokes of a pointed brush, varying the pressure for more interesting marks that suggest the soft, flowing nature of long cat fur.

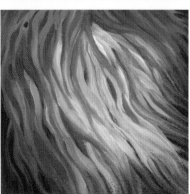

STEP FOUR Now that you have established the middle values, simply continue to build up the lighter values by adding more white to black and yellow ochre. Using the same pointed brush, wipe off the excess paint, and hold your brush from the very tip to ensure more natural, varied strokes. Twist and turn your brush and use varying pressure to create thick and thin lines. By adding a touch of black, you can create cooler, darker grays along the outer edges and anywhere you want the fur to recede. Trace over your strokes with your brush as many times as it takes to achieve your desired softness.

Short Cat Hair

STEP ONE When painting hair or fur, work from dark to light and leave the detail work for the lightest areas. First apply the warm shadows using a ½-inch flat brush and a thin mix of two parts raw sienna to one part black. This transparent layer will provide a dark underpainting while allowing the drawing to show through. Clean your brush and pat it dry, and then use it to lift color from the lightest areas of the fur. This will make it easier for you to build clean, bright whites over the dark background.

STEP TWO To create soft edges within the fur, apply quick, soft marks that you can build on. Use the flat edge of your ½-inch flat brush to loosely paint the darker parts of the fur with ½-inch to 1-inch long strokes and a blend of two parts raw sienna and one part black.

STEP THREE To create the multiple layers of fur in short-hair cats, use the thin edge of a ½-inch flat brush in a zigzag pattern and work your way down the canvas. Build up the basic middle value areas with cadmium yellow medium, a small amount of cadmium red light, and raw sienna to create an orange color. For the white fur, use white mixed with a little bit of black and yellow ochre.

STEP FOUR Lastly, we'll address the fine detail and brighter lights, switching to a small pointed brush. Thin equal parts of white, cadmium orange, and raw sienna just enough to make your color flow smoothly. Use short, delicate strokes that flow in the direction of the hair growth to pull up the highlights in the orange fur. Reload your brush when your marks begin to get rough. Add new brushstrokes to fill in the gaps and suggest depth in your painting. To lighten the white areas of fur, add a small amount of your mixed orange to white, and continue to build up short marks.

13 Horse Coat

STEP ONE Using raw sienna with a small amount of black and a ½-inch flat brush, lay down your underpainting with short strokes in the direction of the hair growth. Unlike cat or dog fur, horsehair is very short and lays flat on the muscle, creating a smooth texture. To achieve this, do not leave too many visible brushstrokes.

STEP TWO To build up the darkest shadow values of this horse coat, use a ½-inch flat brush and a mixture of equal parts of burnt sienna and sap green. With a light touch, apply your brushstrokes in the direction of the hair growth. Keeping your dark values transparent helps them to recede, resulting in the illusion of more depth.

STEP THREE Next build up the reddish middle values of this chestnut coat using an old, stiff #5 round brush. This is where those old, roughly handled brushes come in handy! Mix variations of cadmium orange and burnt sienna lightened with white, and dab your brush into the paint as you spread the bristles apart. This helps create lines in your strokes that resemble hair. Work in the direction of the hair growth, paying close attention to the various muscles and vascular areas under the horse's skin.

STEP FOUR To bring up the lightest areas, use a #1 round and various mixtures of burnt sienna, cadmium orange, and white. Work from dark to light and use short, delicate strokes in the direction of the hair growth to add detail and give volume to the muscles and veining prevalent in the lean contours of the horse's anatomy.

14 Horse Mane

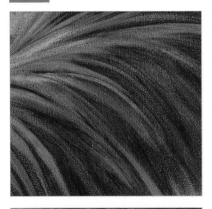

STEP ONE To create the long, somewhat coarse texture of this mane, start by painting the darkest shadows, using a ½-inch brush loaded with two parts of burnt sienna and one part black. Apply the paint in long, full-length strokes that start at the ridge and move toward the ends of the hairs. Use a soft, dry blending brush to trace over the strokes to blur and soften the edges. Clean your brush and pat it dry and then use it to pick out color from the lightest areas. Use the edge of the brush and less pressure as you reach the ends of the hairs to create fine-pointed tips. Wipe your brush clean after every few strokes.

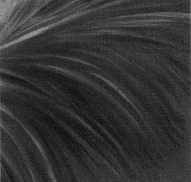

STEP TWO Use the same ½-inch brush to paint the middle value of reddish brown in the mane and on the neck of the horse, using a mix of equal parts of raw sienna, black, and burnt sienna. Cut into this color with a darker color mixed from equal parts of black and burnt sienna to define the dark negative spaces between sections of hair.

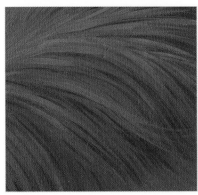

STEP THREE The only difference between the hair of a horse's mane and human hair is that the horsehair is coarser. Using the same long, fine-pointed brush you would use for human hair, apply a mix of raw sienna, cadmium red light, and white to create the reddish colors in the mane. Turn your painting whichever direction is most comfortable for you to paint the entire length of the individual hairs with long, soft, smooth brushstrokes. Work back and forth, arcing your hand to delicately create the curves of the flowing mane. If you have difficulty getting long, smooth strokes, thin your paint for better flow.

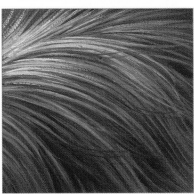

STEP FOUR Now add the final highlights to the hair. Mix two parts white to one part cadmium yellow medium, and add a small amount of raw sienna to neutralize. Thin this mixture so you can create longer, smoother lines. Rotate your painting in whatever direction allows you to get the most natural arch as you stroke. Start at the origin of the hair growth—in this case, the lightest area—and reduce the pressure of your brush as you reach the ends of the hair, lifting your brush right off the painting to achieve fine, soft, wispy ends. If you find that these marks contrast too much with the darks, darken the mix with burnt sienna. Work your way up into the lightest areas gradually.

15 Dolphin

STEP ONE Because dolphin skin is smooth and wet, it is reflective of its surroundings. Start by laying in a smooth, transparent layer of phthalo blue, darkened and neutralized with a touch of black. Thin your paint just enough to reduce the color to a middle value, and apply it using a soft ½-inch brush. Use the pounce technique to eliminate any brushmarks and soften all the edges of color.

STEP TWO To continue building the dark values, mix phthalo blue with a very small amount of black. Using a ½-inch flat brush, work in long, smooth, sweeping strokes that leave no brushmarks. For the lighter, pinkish-gray areas, mix burnt umber with white in varying amounts and retrace your strokes along the edges where the two colors meet until they are smoothly blended with no visible strokes.

STEP THREE Continue to add middle values of blue in the lower left with a ½-inch flat brush and a mixture of one part phthalo blue, two parts white, and one part cobalt blue. This creates the cooler blue found where the skin reflects the water below. For the warmer, lighter areas near the top, add more white and a touch of a cool, earthy red, like Venetian red. Blend the edges between colors together by retracing your lines in long, full-length strokes.

STEP FOUR Using a #2 or #3 round brush, loosely create the final reflections of water that bounce up onto the dolphin's smooth, wet skin with a mixture of equal parts of alizarin crimson and phthalo blue, with a touch of white to brighten. Thin your color so it glides on thinly and smoothly. Using separate water references if necessary, re-create the appearance of water patterns in the darkest shadow areas where they are most clearly seen.

16 Elephant

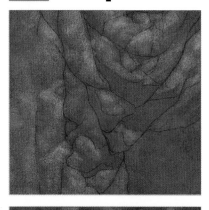

STEP ONE To paint the rough, deep wrinkles found in elephant skin, start by painting an even layer of two parts of burnt sienna cooled down with one part sap green. These are both transparent colors, so they will allow your drawing to show through while creating a warm undertone for the following cooler layers. Using an eraser cloth, remove color from what will become the lightest areas of the skin.

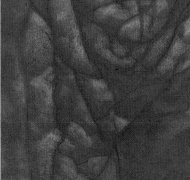

STEP TWO The most important element to capture in elephant skin is the depth and texture of its wrinkles. For the deepest creases and shadows, mix equal parts of black and burnt sienna, with a touch of white to increase the opacity of the color. Using both the width and length of the edge of a ¼-inch flat brush, render the lines and shadows with loose, drybrush texture and soft edges. Wipe off excess paint from your brush before you stroke to help achieve texture.

STEP THREE For the basic middle-value gray that makes up the bulk of elephant skin, mix white with a touch of black. Using a ¼-inch flat brush and short, square strokes, gently paint in the rest of the skin. Use a light touch and try to capture the texture of your board, allowing bits of the original reddish browns to show through, especially in the cracks. Add more white for lighter areas, but don't overwork by adding too much paint.

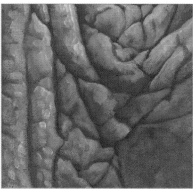

STEP FOUR Once your previous layers are dry, add more white to your gray mixture and a bit of yellow ochre to warm it up. Continue using your ¼-inch flat brush and wipe off most of the excess paint from your brush and then paint the lightest highlights of the rough elephant skin. Use the texture of your canvas or board to build texture with the drybrush technique and short, impressionistic strokes. Do not blend. Instead, leave your marks very painterly.

17 Snake

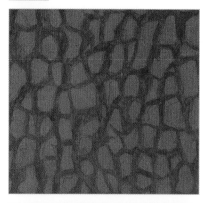

STEP ONE To paint the raised pattern of snakeskin, begin by painting an even layer of transparent burnt sienna with a ½-inch flat brush. Remove all brushmarks with the pounce technique. Darken the burnt sienna with a small amount of black and, using a small pointed brush, paint the dark shadow area between each scale.

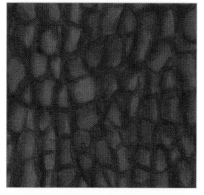

STEP TWO Next focus on creating the shadow side on the left and bottom of each individual scale. Use a fine-pointed brush loaded with a mix of equal parts of burnt sienna and black. To blur the edges and start modeling the roundness of the scales, lightly brush over the scales with a soft, dry brush.

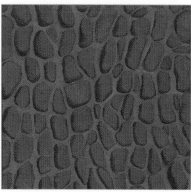

STEP THREE Snakeskin texture has very defined patterns with fairly hard edges. This texture is usually shiny and often colorful. Using your ¼-inch flat brush and a mixture of yellow ochre and cadmium red light, carefully lay in the middle value on top of each scale. Load your brush so that each section takes only one brushstroke. To soften some of the edges, wipe the excess paint from your brush on a cloth and trace over the edges of your marks. Use a mix of equal parts of raw sienna and cadmium yellow medium for the color between the raised scales. Use a fine-pointed brush to carefully paint in this lighter value, careful not to cover up the shadows on the left side of the individual scales. Carefully round any corners that have become sharp and angular.

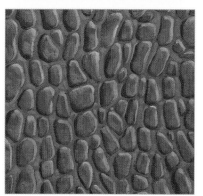

STEP FOUR Lastly, add the final highlights. Mix a very small amount of black and white, adding yellow ochre or raw sienna to warm up the color. Using your small pointed brush, wipe off the excess paint on a cloth so that your strokes are not solid and have a drybrush look. Paint the highlights along the top and right edge of each individual scale. If the white is too strong, try using your finger to gently tap down the color to blend. Add a touch of burnt sienna for highlights that are too dull. Remember: The brighter the highlights, the shinier the snakeskin.

Leopard

STEP ONE To add warmth to the leopard pattern, start with a wash of three parts raw sienna to one part black. Thin the color so you can still see your drawing through the paint.

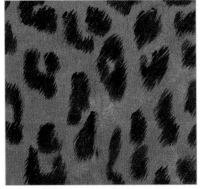

STEP TWO Warm up black with a small amount of raw sienna and use a pointed brush to create the dark spots of the leopard pattern. Working in the direction of the hair growth, use a light touch at the beginning and end of each short stroke to create the effect of fine hairs lying flat against the body. Allow some of the golden underpainting to show through for finer detail.

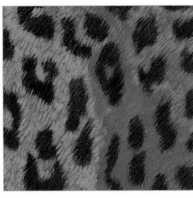

STEP THREE With a fine-pointed brush, create highlights in the black fur using black lightened with a bit of white. For the middle values of the white fur, use white with a small amount of yellow ochre and black to create short, fine marks in the direction of the hair growth, allowing some of the underpainting to show through.

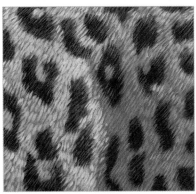

STEP FOUR Finally, enhance your brightest highlights. This is a job for your finest pointed brush. Add a small amount of raw sienna to white and use small, short, pointed brushstrokes to paint the brightest highlights in the fur, always working in the direction of the hair growth. For the darker areas in the shadows, add black to your mix and more raw sienna, if required. Continue with the same kind of brushmarks, adding more texture. You can also use the same color to brighten the highlights in the black spots.

19 # Zebra

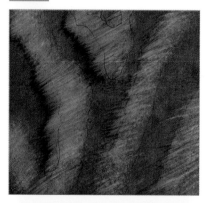

STEP ONE Before you begin to paint the black-and-white striped zebra pattern, create a warm, dark underpainting using three parts black to one part burnt sienna. This adds variety and depth to the overlaying values as long as you allow some of these warm tones show through the fine zebra hairs. Use a 1-inch fan brush moistened with a little mineral spirits (if using oil) or water (if using acrylic) to start establishing the scratchy texture by pulling out color in the white stripes.

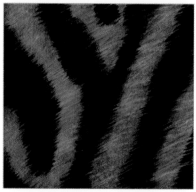

STEP TWO Warm some black with a small amount of raw sienna and, using the edge of a ½-inch flat brush, paint the darkest areas of the zebra stripes. Use short, thin strokes in the direction of the hair growth, being careful not to cover all the underpainting. This will quickly produce the fine, lighter hairs of the black stripes and result in a more integrated pattern because all the areas share the same warm color underneath the details.

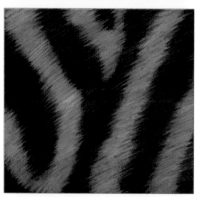

STEP THREE Mix black with a small amount of white and use the edge of your ½-inch brush to create medium-length, straight marks that move from the black areas into the white areas. For the white stripes, use the same brush and a mixture of white with a small amount of yellow ochre. Work in the direction of the hair growth and stretch your marks slightly into the surrounding black areas. This will create realistic transitions between the black and white stripes.

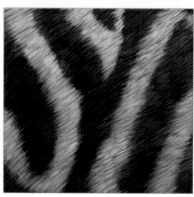

STEP FOUR Now add highlights within the white stripes. Mix white with a small amount of black and a touch of cadmium yellow medium to create a very light, warm gray, and build up the whites in several layers. Always let the previous layer of paint dry before adding another to maintain the definition of your strokes. Also, make sure your lines extend into the black stripes a bit to create soft edges. If you'd like to try painting multiple hairs per stroke, experiment with a fan brush.

Starfish

STEP ONE To achieve the texture of a starfish, you can use nontraditional tools such as cotton swabs. Begin by using a flat brush to lay down an even, reddish layer made from three parts burnt sienna to one part black. Use the pounce technique to eliminate the brushmarks. Dampen the end of a cotton swab with mineral spirits (if using oil) or water (if using acrylic) and pat it dry. Then gently dab the swab and lift out circular areas of color to reveal a bumpy pattern.

STEP TWO Create the shadows found on the right sides of the raised bumps by using the corner of a small flat brush or a cotton swab to dab on a mix of equal parts of black and raw sienna. Continue to build the texture in the flatter parts with this same technique, allowing some marks to be more subtle than others as the paint diminishes on the brush or swab.

STEP THREE For the raised round bumps found on the starfish, start by mixing equal parts of yellow ochre, cadmium red, and white on your palette. Dab a cotton swab into the mixture and onto your painting where you desire. Each time you dab with the swab, the mark will be softer because there will be less and less paint on the tip. You can dab over your spots with a fairly dry swab to soften them even more and create the illusion of depth. Add more white to your mixture and begin adding the lighter values found on the white bumps.

STEP FOUR To create the lightest bumps of the starfish, continue to use cotton swabs, switch to a small round brush, or use a combination of the two. Mix white with a very small amount of cadmium yellow medium to create the warm highlights of the bumps. Gently dab your swab in the mixture, spinning it in the paint to curl up any loose cotton strands that may distort your clean circles. More pressure will result in larger circles with harder edges, and less pressure will give you smaller, more delicate circles that have less contrast. Try not to cover up the color you put down previously; rather, leave some as the shadow edges of your bumps to give them more dimension. Keep your brightest whites and sharpest edges where you want to attract the eye of the viewer, such as the center of the starfish.

21 Feathers

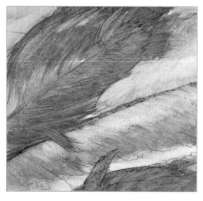

STEP ONE Painting feathers is fun and easy once you master a few brush techniques. The easiest way to start is to establish the shadow colors. Mix a neutral purple of equal parts of alizarin crimson and Payne's gray. Thin it enough to reduce it to a middle value that will remain transparent, similar to a rich watercolor wash. With a ½-inch flat brush, work in the direction of the feather's pattern with long, smooth strokes. For more detailed areas, use the tip of the brush to create fine lines.

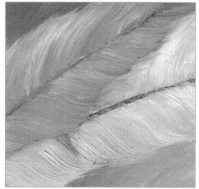

STEP TWO Create a mixture of three parts white to one part yellow ochre for the lightest feather. Thin it enough to make it flow smoothly without losing the body of the paint. Tap a small fan brush into your mix, so that the bristles spread out and separate. Work from the center stem outward following the natural curve of the line pattern. Finish each stroke with a quick sweep to the right as you lift the brush off the canvas. Add burnt umber to your mix for the darker feathers and use the same types of strokes, overlapping the feathers and allowing the colors to blend wet-into-wet.

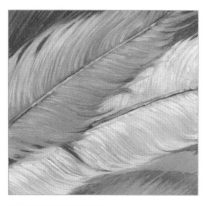

STEP THREE To clean up the edges and add more specific detail, use a #1 round brush and a mixture of one part black to two parts white to paint shadows between and around the separated parts of the feather. Use the same mix to paint the stems before adding final highlights with pure white. If you want to add more highlights to the feathers themselves, simply use the same brush and work carefully in the direction of the pattern, starting from the stem and working toward the ends.

TIP

A fan brush can help you achieve delicate, parallel strokes that are perfect for creating the subtle textures of grass, feathers, and fur. However, using a fan brush effectively requires some practice. Subtlety is best achieved with dry or moist (but not wet!) brush hairs and minimal paint. You may even want to stroke the brush on scrap paper or a cloth before touching your canvas to avoid small blobs of paint.

Butterfly Wing

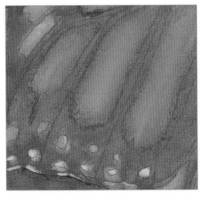

STEP ONE This monarch butterfly wing is basically a pattern. To save time, start with a semi-transparent orange mixed with one part cadmium yellow light and one part cadmium red light. (You can also use cadmium orange.) Thin the paint while retaining its vibrance, and paint over the entire wing. Use a cotton swab or piece of cloth to pick out only the white areas of the wing. Use the pounce technique to eliminate your brushmarks.

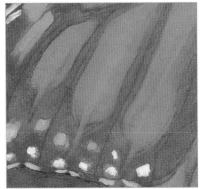

STEP TWO Next focus on painting in the lightest oranges and whites. Because you will be cleaning up the pattern with blacks later, don't worry about accuracy in these initial layers. Also, keep in mind that you may need to apply multiple layers of white to achieve your desired brightness. Let each layer dry before adding another. Add cadmium yellow light to your orange mix to increase the opacity and build up some variation in the lighter orange sections using a ½-inch flat brush.

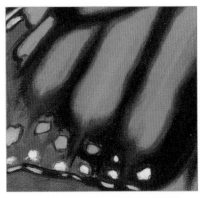

STEP THREE Now it's time to paint the black parts of the pattern. Start by tracing around the colored sections with soft, drybrush lines that act as a transition edge between the darkest blacks and the very bright colors. Use a #2 round brush and a mixture of equal parts of black, cadmium orange, and cadmium red light. Once you are satisfied with your gradation, add more black to your mixture and continue to fill in the rest of the black areas.

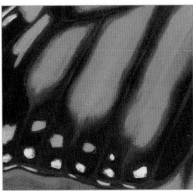

STEP FOUR Once you've finished massing in the warm blacks, add a touch of white to the mix and use a #1 round brush to add the fine detail along the veining between each section of color and along the edge of the wing. Keep these lines soft and subtle so they read as highlights falling on raised areas.

23 Spider Web

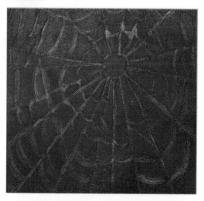

STEP ONE Begin the spider web by laying in your background. Use a ½-inch flat brush to paint an even layer of green made of equal parts of sap green and yellow ochre. Remove all your brushmarks with the pounce technique or by using a very soft, dry fan brush. Next, pull out some of this green color with a #2 round brush that is damp with mineral spirits (if using oil) or water (if using acrylic). Wipe off the color on a cotton cloth as you work.

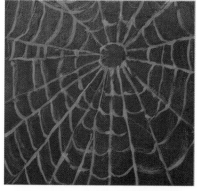

STEP TWO Before painting the brightest lights of the spider web, establish lines with a bright green mix of equal parts of cadmium yellow light and green gold hue (or an equivalent). Thin it enough so you can draw very fine lines with a #1 round brush. Pay close attention to how the strands sag toward the bottom of the web to make it feel more natural.

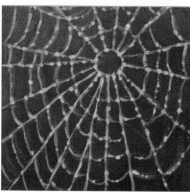

STEP THREE To finish the spider web and capture the effect of dew resting on the web, use a fine #1 round brush and a very delicate touch. With a thin mixture of white and a touch of cadmium yellow light, retrace some of the lines, especially where they meet and come into the sunlight. Dab tiny spots the mixture at random places along the threads to represent dew.

TIP
To paint old, dusty cobwebs, which are less orderly and intricate than spider webs, simply build up soft glazes of white or light gray. Use the tip of a fine brush to add thin strands for detail.

Notes

FABRICS & TEXTILES

COLOR PALETTE

• alizarin crimson • burnt sienna • burnt umber
• cadmium orange • cadmium red light
• cadmium red medium • ivory black • Payne's gray
• phthalo blue • raw sienna • sap green
• titanium white • ultramarine blue
• Venetian red • yellow ochre

24 Burlap

STEP ONE Mix equal parts of burnt sienna and sap green to create a warm, natural brown underpainting. Once dry, mix a stronger version of this color and begin the rough but simple weave of burlap. Use a ¼-inch flat brush on its edge to paint a gridlike pattern, which will serve as the shadow lines between threads. Wipe off the excess paint from the brush onto a cloth so your lines are soft and dry and your strokes pick up the canvas or paper texture.

STEP TWO Begin painting the weave of burlap by applying short, organic strokes that cross over two squares of the grid. Use a ¼-inch brush and a mixture of equal parts of burnt sienna and yellow ochre. As you lay down the strokes, stagger each row by one square, as shown.

STEP THREE To create the cross sections of the weave, mix equal parts of burnt sienna, white, and yellow ochre, and use a ¼-inch flat brush to create short strokes across the mid sections of the opposing threads. Work in the opposite direction of your first set of marks; for this reason, you might find it more comfortable to rotate your painting.

STEP FOUR The final details and highlights bring the separate weaves together and make it appear more cohesive. To finish, use a #3 round brush to make a cross on the top of each section of the pattern. Using equal parts of white and yellow ochre, begin by hatching in one direction so the strokes line up. Then rotate your painting and apply crosshatches in the opposite direction, keeping your marks soft so they blend with previous layers.

25 **Wool**

STEP ONE Painting wool is similar to painting most woven fabrics, but it features a signature pattern. Mix equal parts of burnt sienna with sap green and thin the paint without losing the strength of its color. With a ½-inch flat brush, paint an even, transparent layer of color over your entire surface. Next begin establishing the pattern using a #2 round brush. Wipe off the excess paint from your brush onto a separate cloth and then loosely draw the lines between the threads.

STEP TWO Use a #1 round brush and a mix of equal parts of burnt sienna and sap green to redraw the shadows in the pattern. While this is still wet, switch to a #3 round brush and mix yellow ochre into your shadow color to create a warm middle value. For each thread of the braid, place the tip of your brush in the top corner and increase your pressure, thickening the stroke; then reduce your pressure as you end the stroke softly. Turn your painting to the angle that feels most natural for your strokes.

STEP THREE Blend and soften the edges and re-establish the shadows by tracing over the drawing with a #1 round brush and a thin mixture of burnt sienna and sap green.

STEP FOUR Once dry, use the same brush to add brighter highlights and more texture to your pattern. Mix yellow ochre with a touch of white, and wipe off the excess paint from your brush before stroking. Add two or more strokes on some sections to create the look of yarn.

Tweed

STEP ONE To start the herringbone pattern of this classic tweed, begin with a dark, transparent layer of two parts burnt umber to one part ultramarine blue. Use the pounce technique to eliminate brushstrokes and to even out the color until your drawing shows through. With a #2 round brush, begin to draw the shadow lines between the rows of the pattern.

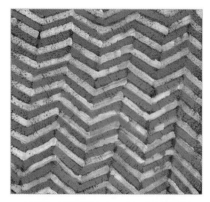

STEP TWO Working in the opposite direction of the pattern you created in step one, use a #2 round brush loaded with pure white to paint the cool light areas of the herringbone pattern. Any color combination will work, depending on how traditional you want to be. Reload your brush after each stroke.

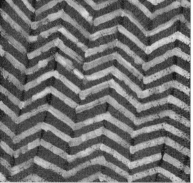

STEP THREE For the neutral yellow threads, use a #1 round brush loaded with a mix of two parts yellow ochre to one part white. Reload for every section, and keep your strokes loose and organic, allowing the dark underpainting to peek between the stripes.

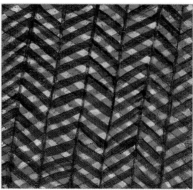

STEP FOUR For the final dark sections of the pattern, mix equal parts of black and ultramarine blue and brighten with a touch of yellow ochre or white. Thin it down into a glaze so the color allows your earlier layers to show through subtly. Use your #1 round brush to paint stripes in the opposite direction of your previous gold and white stripes. Lastly, clean up the rows between sections with a fine line and the dark glaze.

27 Plaid

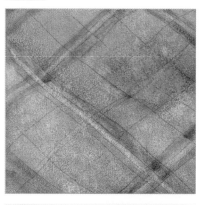

STEP ONE Painting the seemingly complex patterns of plaids is easy once you learn how to layer transparent colors. For this plaid, begin with the blue foundation color. Use ultramarine blue neutralized with a touch of Payne's gray. Thin the mix until it is a light-to-medium value. Using ½-inch and ¼-inch flat brushes, lay in the color, working in the direction of the stripes. Allow this layer to dry before you move on to the next color.

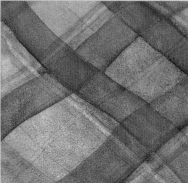

STEP TWO Use the same brush to establish the red stripes. Thin cadmium red light to a medium-to-light consistency, and load your brush with enough paint to complete one whole stripe with a single brushstroke. If you must retrace your stripe, do so softly and quickly to avoid overworking and pulling out color.

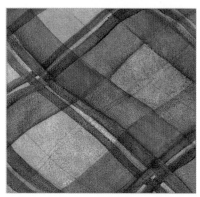

STEP THREE Next we'll begin to bring the plaid pattern into focus by painting the finer stripes. Using a #2 round brush loaded with a glaze of equal parts of ultramarine blue and alizarin crimson, work from one end to the other, painting right over the other colors. By varying the degree to which you thin your paint, you can adjust the strength of the color. Remember not to overwork glazes and to let them dry between each layer.

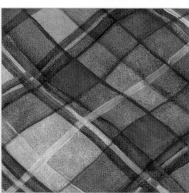

STEP FOUR Now add one more diagonal stripe using a thinned version of the glaze from step three. Then use a fine-pointed brush loaded with thin white paint to add a few final strokes following the direction of the pattern. Plaids can be as complex as you want, and you can keep adding stripes, colors, and layers to achieve whatever combination you desire, as long as you allow each layer of glaze to dry before adding another.

Denim

STEP ONE Start by applying a layer of gesso to your board with a bristle brush. (See "Preparing You Support," page 9.) Use long strokes to create a texture of vertical lines that will show up later as the thread texture of the denim. Once dry, stain your surface with a wide flat brush and a transparent mixture of thin raw sienna, painting in the opposite direction of your surface's texture. You may instead choose to paint on linen canvas or board, as it already features this vertical texture.

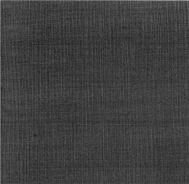

STEP TWO To create the blue cross-weave of denim, simply use a thin mixture of ultramarine blue and a touch of black. You can change this blue depending on what kind of denim you are painting. Use a large ¾-inch flat brush, sweep across the grain of your board's texture, completely covering the warm underpainting. Finally, use the edge of a large, flat sponge to swipe across the grain to lift some of the blue glaze, exposing the warm tones beneath and creating horizontal striations that look like threads. (See "Sponging," page 13.)

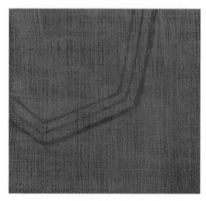

STEP THREE To continue building the texture and lighter blue threads of the denim, add more ultramarine blue and white to your previous mix. Wipe off the excess paint from a ¾-inch flat brush and softly drag it across your support in long horizontal strokes. Lay your brush as flat as you can so it is almost horizontal to your painting. The paint will catch only the tops of the texture and will not work into the grooves where the underpainting is exposed.

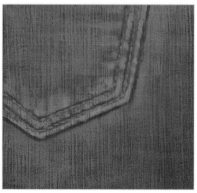

STEP FOUR For the lighter, worn areas around the stitching, add more white and yellow ochre to the mix. Use a #3 round brush to carefully add detail with the drybrush technique to emphasize the texture and avoid covering the colors from your first layers. Use yellow ochre lightened with white and a #1 round for the stitching.

29 Cotton

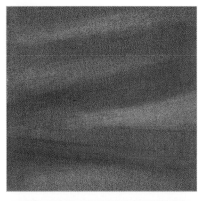

STEP ONE To create simple, white cotton cloth, start with a warm gray underpainting made from a mix of equal parts of black, ultramarine blue, alizarin crimson, and white. Using a soft rag, paper towels, or cotton swabs, wipe off some of the color in the lightest areas to begin establishing your light source.

STEP TWO For the middle values, mix one part black, one part ultramarine blue, and four parts white. Using a ¼-inch flat brush, work from the lightest areas in long strokes that follow the length of the folds. Work toward the shadows as you reduce the paint on your brush, blending your color into the darkest parts of the underpainting without completely covering them. Dark, cool, transparent colors recede whereas light, warm, thick colors appear to come forward. Keep your shadows semi-transparent and your lights thicker.

STEP THREE Continue to build your lighter values by adding more white to your mixture and using a ¼-inch flat brush to cover the rest of your drawing and underpainting. As you move into the lighter values, don't be afraid to use more paint and allow for more texture.

STEP FOUR For the warmer, brighter light at the tops of the folds, use pure white with just a touch of yellow ochre warm it. After wiping the excess paint from your brush, use a ¼-inch flat brush to work in long strokes along the length of each fold that is hit by the primary light source. The flatter you keep your brush in relation to the support, the more texture you will capture. After removing most of the paint from your brush, drybrush over the bottom of each fold in the shadow areas to enhance the reflected light bouncing up onto them. Keep the receding edges soft and blended into the shadows.

Silk

STEP ONE For this bright purple silk, start with a thin underpainting of equal parts of ultramarine blue and alizarin crimson. Use a balled-up cotton cloth to pounce out the brushstrokes without removing color. To establish the highlights on the folds, roll up a small piece of cloth into a point and gently wipe away some of the color.

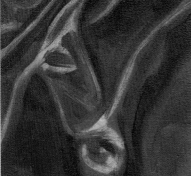

STEP TWO For the cool purple midtones, mix equal parts of ultramarine blue, phthalo blue, and alizarin crimson. Use a ¼-inch flat brush and work in the direction of the folds in long, smooth strokes, avoiding the lightest areas. Next add more alizarin crimson and black to your mixture for the darkest shadow areas. Work wet-into-wet to create soft, blended edges between the midtones and the deepest shadows.

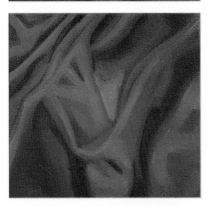

STEP THREE Cover the lightest areas in the rest of your drawing with a bluer mixture of two parts phthalo blue, one part alizarin crimson, and three parts white. Use a ¼-inch flat brush on its side and edge, depending on the width you need. Keep your turns more angular with less blending at this stage.

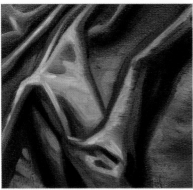

STEP FOUR For the final reflective highlights, mix one part phthalo blue with three to four parts white. Use a ¼-inch flat brush to create quick, unblended marks across the curves of the folds, switching to a #3 round for the ridges. Leave your marks painterly and allow the lines of your brush hairs to show, replicating light hitting the linear weave of the silk.

31 Satin

STEP ONE Using a ½-inch flat brush, create a thin mix with equal parts of cadmium orange and cadmium red light for the underpainting. Pick out the lighter areas with a small cotton cloth rolled to a point. Be careful not to let the rest of your cloth touch the wet paint on your canvas.

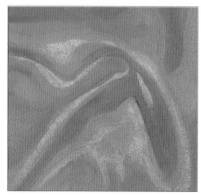

STEP TWO For the pinkish middle values, mix equal parts of cadmium orange, alizarin crimson, and white. Use a ¼-inch flat brush and work in the direction of the folds, avoiding the lightest areas. Next add more alizarin crimson to your mixture to darken it for the shadows. Work wet-into-wet to create soft, blended edges between the midtones and the deepest shadow areas.

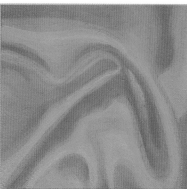

STEP THREE Next continue building your lighter values by adding white to your previous mixture and creating a base for the final highlights, which will bring out the unique shiny qualities of the satin. Cover the remaining areas of the underpainting using a #3 round and ¼-inch flat brush, depending on the size of detail required. Trace over your long strokes to blend the edges into the darker areas.

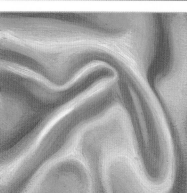

STEP FOUR To finish the lightest areas, add white in various amounts to your previous mixture and, using a #3 round brush, build up impasto strokes along the ridges of the folds, with long, soft, blended marks. (See "Impasto Strokes," page 15.) Keep your curves round and smooth, rather than angular and hard, to illustrate the heavy weight and thickness of satin.

Velvet

STEP ONE Using a ½-inch flat brush, apply the deep, rich shadows of this blood-red velvet with an even layer of equal parts of black, Venetian red, and alizarin crimson. Use the pounce technique to eliminate your brushstrokes and create a soft, even texture similar to that of velvet.

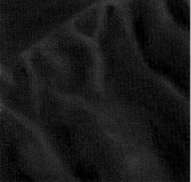

STEP TWO To create the dark and middle tones of velvet while capturing its texture, work from dark to light with variations of black and Venetian red. Add more red after you have completed the shadows and move toward the highlight areas, working wet-into-wet for soft, blended edges.

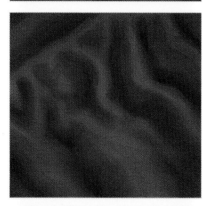

STEP THREE Next add more Venetian red and white to continue building your values from dark to light using the drybrush technique for a velvety effect. Keep all your forms very curvy and soft, blending smoothly between the values.

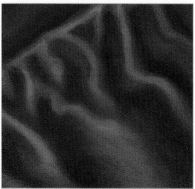

STEP FOUR Use equal parts of cadmium red light, Venetian red, and white for the final highlights. After wiping the excess paint from your #3 round brush, softly brush across the tops of your support's texture to capture the graininess of velvet and to build depth and contrast.

33 Leather

STEP ONE Begin by laying down a thin but rich blend of equal parts of burnt umber and burnt sienna with a 1-inch flat brush. Go over your marks to eliminate the brushstrokes. To create the texture of the leather, use a smooth, damp sponge to lift color from your surface. A flat sponge with holes of various sizes works best.

STEP TWO Because the creases in leather suggest realistic wear and tear, take some time to pull out their details with a #3 round brush and thin burnt umber. Keep the lines organic and natural, varying the thickness. If they are too strong, simply use your finger or a dry brush to soften them.

STEP THREE To enhance the light falling on the leather's mottled surface, mix a reddish gray from one part burnt sienna, one part black, and three parts white. Using a #3 round brush, add highlights to the bottom and left edge of each line. Then switch to a ¼-inch flat brush and lightly drybrush across the areas where the light source is the strongest. To further soften the creases, lightly brush over the lines.

STEP FOUR For the lightest lights, mix equal parts of burnt sienna and white grayed with a small amount of black. With a ¼-inch flat brush, use the drybrush technique to add light to the areas of the leather that reflect the most light. Use a small #1 round brush to add delicate highlights to the top and right edges of the creases. Allow the warm underpainting to show through wherever possible.

Patent Leather

STEP ONE Lay down a layer of solid black. Let this dry, and then use a white colored pencil to sketch the main shapes on the black.

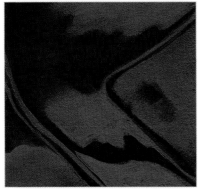

STEP TWO To start building the light reflections, add small amounts of white to your black. Using a ¼-inch flat brush, wipe off the excess paint and fill in the reflections. Pay close attention to their shapes and blend the edges by swiping your almost-dry brush from the center of the reflection out into the black, lifting the brush away from the surface to create a gradation.

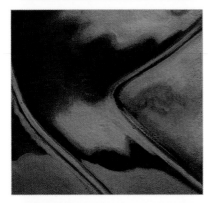

STEP THREE After your last layer has dried, continue to build up the lighter highlights with a ¼-inch flat brush, and add more detail to the seams with a #2 round brush. This will create a base for your final highlights.

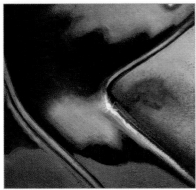

STEP FOUR Using pure white, add the final highlights to the thin piping of the patent leather with a #2 round brush. Use a ¼-inch flat brush for the larger areas after wiping the excess paint from your brush. Apply a thick dab of white for the brightest highlight, softening it with a dry brush to give it that final "bling!"

35 Sequins

STEP ONE Establish your middle value first with a thin even layer of equal parts of ultramarine blue and alizarin crimson. Use a ½-inch flat brush and then eliminate all your brushstrokes with the pounce technique, or by softly stroking over them with a very soft, dry 1-inch flat brush.

STEP TWO Next cut the pointed end off a ⅜-inch drawing stump with a utility knife to create a flat, round end. You can use this tool to create repeated circles of paint on your canvas. (You can also use the end of a stick eraser.). Start with the darkest shadows around and in between the sequins. Mix equal parts of black, alizarin crimson, and ultramarine blue, and spread a thin layer on your palette using a palette knife. Roll the edges of your modified stump into the paint, and then roll it off on your painting in a circular motion. If there is too much paint on the stump, simply pat it on a rag before rolling. Reload between each circle. When finished, use a dry #3 round brush to smooth out the texture in the center of each ring and to remove any excess paint.

STEP THREE When this layer is dry, mix a lighter purple with equal parts of ultramarine blue and alizarin crimson lightened with white. Dab the end of your modified stump or eraser tip into the paint, roll the excess paint off the edges onto a rag, and press it into your surface at the center of each of the rings made in step two. Experiment with pressure and the quantity of paint on your stump until you achieve a smooth, full coverage. Reload between each sequin. Before these dry, use a #3 round brush to remove the texture from the center of each circle so it resembles the smooth the surface of sequins.

STEP FOUR To add highlights along the upper edges of the sequins, apply various mixes of alizarin crimson, phthalo blue, and white with a fine #1 round brush. The greater the contrast, the more reflective they will look. Use the same brush and a dark purple mixed with equal parts of ultramarine blue and alizarin crimson to add delicate little threads from the center to the edge of each sequin.

Lace

STEP ONE A pattern painted with semi-transparent colors will allow the variations of your base color to show through, resulting in a more integrated pattern. For this white floral lace, begin by painting a skin tone with equal parts of black, cadmium red light, and white. To hint at the shadow of the netting on the skin, lay a dry piece of paper towel (or even an actual piece of lace) onto this wet surface, pressing into it gently and evenly to lift some of the color.

STEP TWO Paint a thin, semi-transparent layer of white over your entire underpainting and let it dry. Next, add a small amount of black to your base color and, using a fine #2 round brush, carefully draw the basic outlines of the lace pattern onto your surface. These darker lines should be soft but clear and will act as subtle shadows cast around the thicker, sewn parts of the lace pattern.

STEP THREE Once the previous layer is dry, use a #3 round brush and thin white paint to mass in the flat, medium-value white of the primary lace detail.

STEP FOUR Bring out the final details by enhancing the thicker, whiter stitched edges within the lace. Use a #1 or #2 round brush loaded with white to trace over these edges and add dimension within the pattern.

Straw Hat

STEP ONE Start by applying a thin, even layer of burnt umber with a ½-inch flat brush. Use a soft, dry brush to blend your brushstrokes until you can see your drawing through the paint.

STEP TWO Next add more detail to the shadows between the rows in the weave using a #3 round brush and thin burnt sienna. Hold your brush toward the end of its handle, and allow it to make natural lines of varying thickness and density.

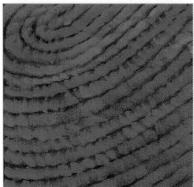

STEP THREE With the warm underpainting finished, start painting the gray shadows of the hat and the individual rows of woven straw using equal parts of raw sienna and black, lightened with a small amount of white. Wipe the excess paint off your ¼-inch flat brush before working row by row in a zigzag motion, allowing the browns to show through.

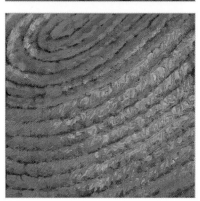

STEP FOUR Use various mixtures of yellow ochre and burnt sienna lighted with white and a #3 round brush to dab thick spots of loose, painterly color to your surface where the light hits the rows. Create the impression of woven straw by using the pointed end of a small palette knife to scratch into these dabs of paint, spreading them out and blending them into the darker, cooler grays.

Woven Basket

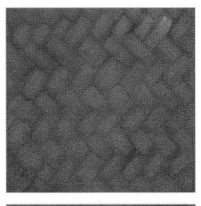

STEP ONE Create a detailed drawing that will show through your paint layers and act as a guide for your darkest darks. Then use a 1/2-inch flat brush to lay in your underpainting with a medium-value mix of equal parts of black, ultramarine blue, cadmium red medium, and white. Thin the paint until you can see your drawing clearly through the color. Next use a dry ¼-inch flat brush to pull some color off the lighter areas of each section of the weave. Wipe your brush onto a cloth between sections.

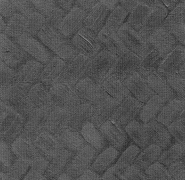

STEP TWO After your underpainting is dry, create a mix of one part ultramarine blue, two parts alizarin crimson, and six parts white. Lay in the middle values of the purple in each individual section of the pattern using a ¼-inch flat brush.

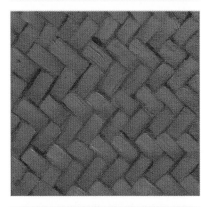

STEP THREE Next lighten your mixture with more alizarin crimson and white to add the warmer, lighter values to each section using a ¼-inch flat brush. Darken the shadows between sections using thin burnt umber and a #3 round brush.

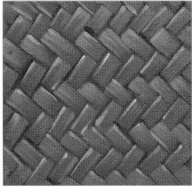

STEP FOUR Now mix one part alizarin crimson, one part ultramarine blue, and four or more parts white for the highlights. Use a #2 round brush to add this color along the lightest edges of each section of the weave. Add more striations to suggest detail. Start at the top of each section and complete each highlight in one smooth stroke so it thins and softens out the end. A few small dabs of lighter color will make the material look more reflective.

GLASS, STONE, CERAMICS, WOOD & METAL

COLOR PALETTE

- alizarin crimson • burnt sienna • burnt umber
- cadmium orange • cadmium red light • cadmium yellow
- cobalt blue • green gold hue • ivory black • Payne's gray
- phthalo blue • raw sienna • sap green
- titanium white • ultramarine blue
- Venetian red • yellow ochre

Beveled Crystal

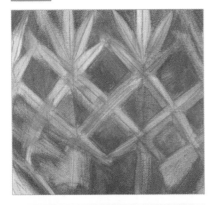

STEP ONE When using oil or acrylic to paint glass, it's important to create the illusion of transparency. You can achieve this using a combination of glazes and semi-glazes—similar to working with watercolors. For beveled crystal, pay close attention to the shapes etched into the surface, and build your painting from a transparent background to a more opaque foreground. Start with a transparent glaze of gray mixed from black and very small amounts of alizarin crimson and ultramarine blue. A ½- or ¼-inch flat brush works well to loosely lay in the shadow areas. Retrace your strokes to eliminate any visible brushmarks, but allow variations in the values to create depth and suggest light coming through the glass.

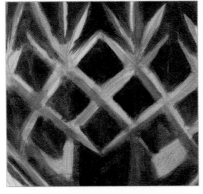

STEP TWO In this step, continue to build the cuts of the glass with thin washes of black. A small ⅛-inch flat brush or #4 round brush will give you the control you need, but don't worry about being too meticulous at this point; you can always clean up your edges in the last layers of detail work.

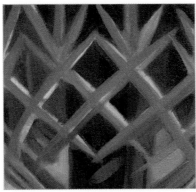

STEP THREE With the background in place, switch to a smaller ⅛-inch flat brush or #2 round brush to begin painting the darker sides of the glass cuts. Create a purple-gray using white tinted with small amounts of black and Venetian red, thinning the mixture to ensure a fluid line as you work from one end of the cut to another.

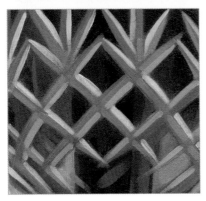

STEP FOUR Finally, using a #2 round brush, add a light blue mix to the light side of each cut, cleaning up the shape of each beveled edge as you go. Create each section in one clean stroke from the top to bottom, resulting in a natural gradation as the paint becomes thinner on your brush.

40 Clear Glass

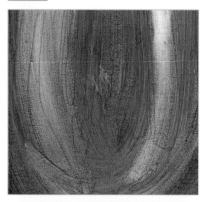

STEP ONE For clear glass, start with a wash of ultramarine blue, a touch of alizarin crimson, and Payne's gray. Thin down this mixture to a medium-value wash. Use a large, soft flat brush to quickly lay in the midtones using long strokes that follow the contour of the glass. Note: If you would like to eliminate drying time in the early stages of an oil painting, you can always paint your first layers with acrylic, then add oils on top of them. However, you can't paint acrylics over oils.

STEP TWO Before you move on to the lighter values and reflections of the glass, create a dark background that will contrast with these details. Various mixtures of black, white, and ultramarine blue are perfect for the neutral blue-grays of this glass. Thin your mixtures and use a ½-inch flat brush to sweep smooth color onto your surface in long, broad strokes that follow the curves of the glass. Retrace your marks to knock down the brushstrokes to achieve clean, blended edges that recede into the darker background.

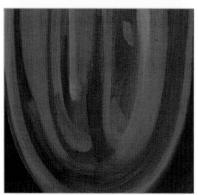

STEP THREE The next step to creating believable clear glass is to focus on adding more reflections. Glass is purely the sum of its reflections, which respond to the surrounding environment. Any colors that are nearby or behind will reflect in the glass. Mix brighter versions of your background colors and thin them to create semi-transparent glazes. When painted over the glass surface, these semi-glazes will allow the underlying colors to show through. Study the reflections in your glass and use a ½-inch or ¼-inch flat brush to capture them with long, smooth strokes that originate at the top edge of the glass.

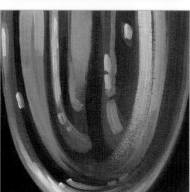

STEP FOUR After all your previous layers dry, add more white to your colors and stroke in a few stronger, more opaque reflections. A few well-placed dabs of dramatic color will also add to the reflective quality of the glass.

Amber-Colored Glass

STEP ONE To lay the foundation for the golden-brown oranges of amber glass, mix equal parts of burnt sienna and yellow ochre, darkening with a small amount of sap green. Then using a 1-inch flat brush to sweep your color in full-length bands across the subject, creating smooth color without brushmarks. You can use a soft, dry brush to soften the edges left behind.

STEP TWO Next add the darker browns found in the shadows of your form using a mixture of equal parts of burnt sienna and black. Then lighten your mixture with more burnt sienna and yellow ochre, and use your ½-inch flat brush to mass in the rest of the oranges that make up the foundation color of the amber glass. Work in long, broad strokes from side to side, and smooth out the brushmarks by retracing them or using a soft, dry brush to lightly knock them down.

STEP THREE With the shadow and middle values of the amber in place, focus on the highlights and final details. Mix equal parts of yellow ochre, white, and cadmium orange, thinning the mixture for a smooth flow. With a ½-inch flat brush, fill in the center area with long, smooth, seamless strokes from side to side, overlapping and blending them with the darker neighboring values. Add more defined reflections on the surfaces facing your light source with a smaller ¼-inch flat brush.

STEP FOUR Finally, after your previous layers dry, add a few strong opaque highlights mixed from cadmium yellow and white. Stroke where the light bounces off the curved surfaces of the glass to really bring the glass to life and enhance its reflective quality. Hold a #2 round brush by the end and lightly add a few squiggly lines with thick paint. Do not blend the edges; instead, allow them to be dramatic and bright against the more subtle colors and textures beneath.

42 Cobalt-Colored Glass

STEP ONE Cobalt glass is very rich and contains a variety of blues. Begin with a wash of ultramarine blue to create a middle value that will serve as a foundation for building deeper layers and reflections.

STEP TWO With the base color in place, continue to mass in the entire surface using dark, cool ultramarine blues warmed with a touch of phthalo blue and thinned for flow. Work wet-into-wet and allow your ½-inch flat brush to create loose brushmarks that mimic the natural surface variations found in cobalt glass.

STEP THREE Continue to add lighter values of blue mixed with cobalt blue and small amounts of white. Using a ½-inch flat brush will help you keep your brushstrokes loose and not overworked. Bring reflected light onto the sides of the glass and where the light shows through the dense areas.

STEP FOUR To give the cobalt glass its reflective surface, add strong, white highlights with a #2 round brush where the light hits the object directly. Also, add more white to your cobalt blue mixture and, using a ½-inch flat brush, intensify the large reflection across the center of the glass to finish your painting.

Porcelain

STEP ONE Most porcelain is milky white with a slightly to highly reflective surface, depending on the smoothness of the surface. It is a good idea to build your values and opacity slowly so that you can create depth and variety by controlling the transparency and temperature of the paint. Using a 1-inch flat brush and long, curved strokes that extend from the top to the bottom, apply a thin underpainting with equal parts of black and white.

STEP TWO Once your initial layers dry, add more white to your paint and continue to build the lighter values where the light source hits the surfaces more directly. Also, indicate where the strongest white highlights will be added later using a ½-inch flat brush.

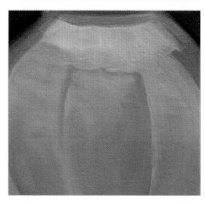

STEP THREE Continue the process of building the lighter values of each separate surface with a lighter variation of thinned white mixed with a touch of black. By building your whites with semi-glazes that are allowed to dry between layers, you will achieve a very translucent surface that resembles porcelain. Pay attention to how the separate sides of your object relate to the light source.

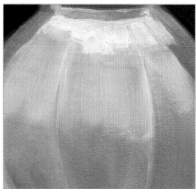

STEP FOUR After your previous layer dries, finish your porcelain by adding another more opaque layer of white where the reflections are the strongest along the top edge. Work your strokes down toward the center of the vase to show its form. It may take many layers to achieve bright whites, so add as many as needed to achieve your desired value.

44 Shiny Gold

STEP ONE Smooth, shiny gold is highly reflective with very dramatic reflections that follow the contours of your form. These reflections resemble the smooth, curving transitions found in water. To start establishing the light logic of your object, create a thin mixture of greenish orange created with equal parts of cadmium orange and sap green. Use a ¼-inch flat brush to achieve the large, flat areas and thin, linear sections. Paint along the flow of the reflections—not against them—and retrace your marks until you have knocked down the texture and blended the edges.

STEP TWO Now that you have gotten to know your subject and its patterns, continue to mass in the different sections of reddish and darker greenish oranges with mixes of sap green, cadmium orange, cadmium yellow, and cadmium red. A ⅛-inch flat brush gives good coverage while offering enough control for detail. Twist and turn your brush to create thicker and thinner marks that flow smoothly along the curves of the reflections.

STEP THREE Having established the darkest reflections and midtones of the gold, it is time to start adding and refining the lighter values on the surfaces that are affected most strongly by the light source. Use variations of cadmium yellow and cadmium orange lightened with small amounts of white. Wipe off the excess paint from your #2 round brush and then apply color to the top edges of each curved section, blending the edges of your marks by retracing them.

STEP FOUR To really bring the gold to life, use pure cadmium yellow and white to highlight the spots that reflect the strongest light. Wipe the excess from your brush and then lay down the paint in long, smooth strokes that blend with the underlying colors at the edges. The more contrast you have between your light and dark values, the shinier and more reflective the gold will appear.

Polished Sterling Silver

STEP ONE The most important characteristics of polished sterling silver are its reflectivity and bright silver color. The strongest reflections respond to the detailing and shapes of the silver, while the softer gradations are reflections of the surrounding environment. Start with a mix of three parts black, one part white, and one part ultramarine blue, thinned slightly for flow. Apply these to the darkest shadows and reflections using a ½-inch flat brush and follow along the contours of the form. Keep your edges soft at this stage.

STEP TWO Unless you have colors from surrounding objects reflecting onto the surface, basic variations of black and white work well for the grays found in silver. Equal parts of black and white create a medium value that is ideal for massing in the midtone areas. Use a ¼-inch brush and work in long strokes that follow the curve of your subject.

STEP THREE Next, add more white to your color and, using a ¼-inch flat brush, begin to paint the lighter middle values along the rim and on the flat center of the plate. Hold your brush at the end of its handle to create loose, organic marks. Your brushstrokes should follow the curves of your form.

STEP FOUR Finally, with either a #2 round or ¼-inch flat brush and pure white paint, add the final layer of highlights on the surface of the silver and along its detailed edges. Carefully observe the patterns that reflect within the silver, and add some to your painting to make it more realistic. Finally, mix a dark gray from black, white, and raw sienna to liven up your shadows and add depth.

46 Pewter

STEP ONE Pewter has a dense, soft appearance that is much less reflective than stainless steel or silver. Also, pewter tends to show quite a bit of wear; the older the object is, the more pock marks and scratches it will have on its surface. Begin by mixing a basic warm, dark gray using black and small amounts of white and burnt sienna. Then use a ¾-inch flat brush to paint the darkest areas with strokes that follow the curves of the form. On the flatter surface areas, drybrush short, impressionistic strokes in various directions to simulate transitions between light and shadow.

STEP TWO After your underpainting dries, switch to a ½- or ¼-inch flat brush and continue to build up the dark to middle values of gray. Use a mixture of three parts black to one or two parts raw sienna, lightened with a small amount of white. Start building the irregular surface texture of the pewter with short, impressionistic strokes that vary in direction. Scratch and tap into the paint with the pointed end of your brush handle to simulate the scratches found on most antique pewter.

STEP THREE Next bring up the values in the lighter areas of the pewter with various blends of ultramarine blue, white, and small amounts of yellow ochre. Add more texture to these areas with short, impressionistic strokes in random directions. Scratch and stab into the wet paint to give the illusion of wear and tear. These marks will become more obvious as you add highlights over them in the next step.

STEP FOUR After your paint dries, finish by painting the light reflecting off the surface. Add more white to the previous gray mixes on your palette and use a ¼-inch flat brush to drybrush the paint onto the surface, turning the marks and scratches from step three into dark details. The edges of your light should be soft due to the rough surface of old pewter. Add more scratches to the lightest areas, working over them until you're satisfied with the texture.

Copper

STEP ONE The older the copper, the more varied and reflective the surface. Start with a rich reddish brown underpainting of burnt sienna darkened with black. To create the watery transitions indicative of copper, first apply a thin layer of medium (if using oil) or water (if using acrylic) to your surface; then apply the underpainting with loose, impressionistic strokes using a ½-inch or ¼-inch flat brush. Your strokes will melt into the prepared surface.

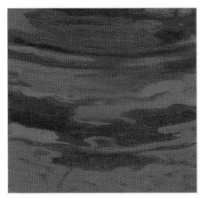

STEP TWO Before you move on to the more reflective colors, mass in the burnt oranges that make up the bulk of the middle values. Create a mixture of equal parts of burnt sienna, cadmium orange, yellow ochre, and sap green. If this is too dark, reduce the sap green to brighten your color. Use a ¼-inch flat brush and medium-length, impressionistic strokes from side to side along the curve of your form. Work wet-into-wet to keep your transitions soft.

STEP THREE The lighter reflections that fall on copper are either cool, light oranges or saturated yellows and whites. First add the cooler reflective lights found on the undersides, where color is bouncing onto the surface from the surrounding environment. Simply cool down your orange mix from step two by adding a little white, and then use a ¼-inch flat brush to add squiggly reflections over the uneven copper surface.

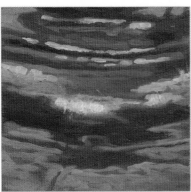

STEP FOUR Now bring out the reflective quality of the copper by dabbing on the lightest highlights where the light source hits the surface most directly and where other objects may be reflecting onto the surface. With a #2 round brush, apply small, impressionistic strokes along the contours of the forms with cadmium orange, bits of cadmium red light, and mixes of cadmium yellow and pure white.

48 Hammered Brass

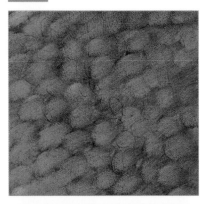

STEP ONE To capture the depth and color variety of hammered brass, use a ½-inch flat brush to apply a smooth, transparent underpainting of sap green mixed with a touch of cadmium red light. Then remove all the brushmarks with a soft, dry brush. Wrap a small piece of cloth tight over your index finger to pull out rounded sections of paint.

STEP TWO Now that you have established the dappled texture of hammer marks in the underpainting, soften it by glazing various combinations of yellow ochre, cadmium red light, green gold hue, and sap green (to darken) over the entire surface. This will partially cover your underpainting and integrate it with the middle values.

STEP THREE Next apply a more opaque layer of color that gradates from warmer, lighter golds (top) to cooler, darker burnt oranges (bottom) using white and yellow ochre darkened with burnt sienna and sap green. Blend this layer with a soft, dry fan brush. Then mix slightly darker variations of your colors and use a ¼-inch flat brush to accentuate the recessed areas with single brushstrokes. These shapes should vary in shape and size to look realistic.

STEP FOUR The final layers will bring your hammered brass to life. The more dramatic your color variations, the more reflective the surface will appear. For example, if your brass is next to a red object, add a bit of red into the divots with a ¼-inch flat brush. If your brass is next to a blue object, reflect blues into the brass. Push these reflected colors randomly into the darker divots with soft, round marks. Finally, punch up the light hitting the raised areas around the divots using the thin brushstrokes of a ¼-inch flat brush and light values of white and yellow ochre.

Clay Pottery

STEP ONE Clay pottery comes in grays and oranges, and—unless it has been glazed—it features a somewhat chalky surface texture. The older and more weathered the pottery, the more variation you will find in its patina. Begin by applying a cool gray underpainting using a ½-inch flat brush and thinned black. Use a slightly stronger wash to define the shadowed ridges and details.

STEP TWO Using various mixtures of Venetian red, white, and black, create the cool red midtones of the clay with the drybrush technique. Wipe off the excess paint from your flat brush and then drag the bristles across the surface of your image, holding the brush handle as low to the support as possible to pick up the texture of the painting surface. Work in short sections of color and stroke in different directions to build more visible texture.

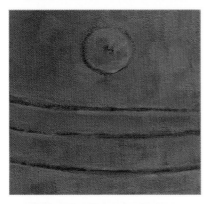

STEP THREE With your cooler shadows in place, start to suggest the pattern of light by drybrushing lighter, warmer blends of cadmium orange, white, and small amounts of Venetian red over the surface. Again, wipe off the excess paint from your brush onto a cloth before dragging the brush over the surface, creating a coarse texture and allowing the colors beneath to show through.

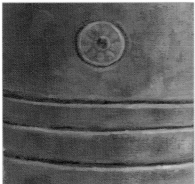

STEP FOUR Finally, with a mix of two parts white, one part yellow ochre, and one part cadmium orange, use a ¼-inch flat brush and a #2 round brush to add brighter color where the light hits your object most directly. Be careful not to cover the colors beneath as they will lend a natural sense of texture and depth to the overall painting.

50 Rusted Steel

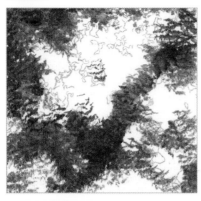

STEP ONE Begin by creating a thin mix of burnt sienna darkened with black for the reddish-brown areas of rust. Dab an old, worn round brush into the color and stipple it onto your surface.

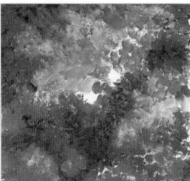

STEP TWO Next build up the rust-colored spots with various mixtures of cadmium orange and yellow ochre for the lighter oranges, adding black for the darker areas. Then create a gray mix of black and white and loosely brush it into the areas of steel. Use a small, worn round brush or the corner of a ¼-inch flat brush to stipple more rust colors into the gray steel to suggest the spreading of the rust. Rust also features small dots of white oxidation, which you can create with a simple mix of white and a bit of black.

STEP THREE At this point, work on filling in the grays of the steel and creating the transitions between the steel and rust. Using a mix of black and white, dab small spots of medium gray wherever the steel shows through the rust.

STEP FOUR Now that you have created the subtle colors of rust as it creeps into the grays of the steel, smooth out some of the areas of gray steel and clean up their edges. Use a small #3 round brush and a light gray mixture.

51 Smooth Concrete

STEP ONE To make realistic looking concrete, build a mottled gray color that has some minor cracks and holes in it. A palette knife is perfect for creating the rough edges and smooth surfaces found in concrete. To begin, mix one part white to two parts black and add a small amount of raw sienna for warmth. Using a small palette knife, scrape paint across your surface in various directions. Be careful to knock down all the texture so you won't have trouble adding layers later. If you do have problems, you can always try sanding down the paint, which can create interesting effects that add to your texture.

STEP TWO Once your first layer dries completely, use your palette knife to continue building up the surface with a mixture of black and white warmed with a touch of raw sienna. Allow the palette knife to determine the texture as you scrape thin layers of paint across your surface in various directions using different pressures. Lay on the paint and scrape it off until you like what you see.

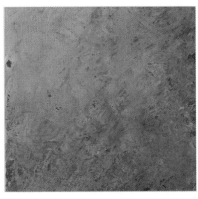

STEP THREE When your previous layer dries, add more white to your mixture and use your palette knife to burnish color onto your surface. The lightest areas should be where the light is strongest and where the concrete moves into the distance, as this area shows less detail and texture than areas nearer to the viewer. Work the paint back and forth or in a circular motion to blend and thin the layer.

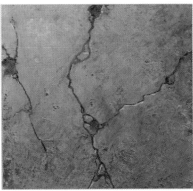

STEP FOUR Now that you have completed the main texture of your concrete surface, all you need to do is add the fine line cracks and pits. Create a dark, warm gray mix and load a long striper brush. Hold the brush at the end of its handle to create natural lines and add a few simple, thin cracks to the surface. Apply sparse white highlights along the light edge of each crack to increase realism and depth.

52 **Stucco**

STEP ONE Basic stucco is a very muddy, greenish gray and can feature various textures depending on how it is applied. Generally, however, it has a mix of smooth and bumpy areas throughout. Start with the darkest areas and build the rougher texture with a mixture of equal parts of black, sap green, and white. Thin the mixture and stain your surface using a ½-inch flat brush, creating texture through loose variations of light and dark values.

STEP TWO Real stucco is applied with trowels, which are essentially large palette knives. To re-create this texture, switch to a small rounded palette knife to scrape and spread the color across your surface. Apply a mix of equal parts of black, white, and raw sienna, allowing the raw edges to remain. Add a few dark patches to break up the surface.

STEP THREE After the painting dries, add more white to your previous color and continue to build the surface texture with a light gray. Use a light touch and allow the palette knife to create natural edges as you dab color onto the surface.

STEP FOUR In this final step, focus on adding highlights along the upper edges of the thicker sections to make them stand out from the base layers. Use a very fine round brush loaded with pure white, being careful not to overwork your strokes. A little goes a long way at this point. Another way to pull up the texture is to drybrush white over the surface by laying your flat brush almost parallel to your image and lightly pulling it across the tops of the highest edges.

Brick

STEP ONE Painting brick is easy when you approach it by building color and light over the darkest shadows. Begin by painting the rough mortar between the individual bricks using the edge of a ¼-inch flat brush and thin black paint. Keep your marks sketchy and round the corners of the bricks to suggest wear.

STEP TWO Using various mixtures of black, Venetian red, and white, paint the basic middle values of the bricks with a ½-inch flat brush. Lay the brush flat on its side and drag it across your surface to achieve the coarse texture of natural brick.

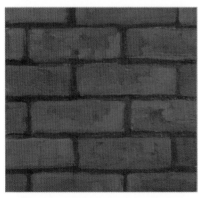

STEP THREE To add characteristic rustic reds and grays to the brick surface, use variations of Venetian red lightened with small amounts of white and cadmium red light. Then apply Venetian red darkened and grayed down with small amounts of black. With a ¼-inch flat brush, paint loose, short, impressionistic strokes that allow the underpainting to show through in areas. Each brick should feature variations of color and value.

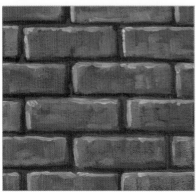

STEP FOUR Now add the lightest reds to the face of each brick using equal parts of Venetian red, cadmium red light, and white. Use short drybrush marks that add to the natural texture of the surface. To finish, add highlights on the top and left side of each brick. Use a #2 round brush with white to add thin, broken lines along the edges, allowing some color beneath to show through.

54 Cobblestone

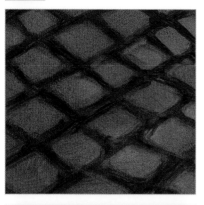

STEP ONE Begin by using a ¼-inch flat brush to paint the darkest shadows between the cobblestones. Create a thin mix of equal parts of black and burnt sienna. Apply an even layer of transparent color; then reload and wipe the excess paint from your brush before loosely sketching the grid of shadows. Continue to blend around the edges of the stones, rounding the edges to suggest years of wear.

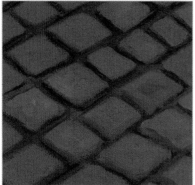

STEP TWO In this step, simply mass in the middle values of dark, warm gray with a ¼-inch flat brush and a mixture of one part burnt sienna, three parts black, and a touch of white. Keep the gray strokes soft as they roll over the edges and into the shadows.

STEP THREE Now mix equal parts of black and burnt sienna and use the corner of a ¼-inch flat brush or a #6 round brush to darken the sides and bottom of each cobblestone. Then add white to this mix to create a middle-value gray for the top surfaces. Keep the cobblestones rustic and textured, varying the values to suggest the worn, irregular surfaces of the stones.

STEP FOUR Finally, add more white to the gray mixture from step three and use a ¼-inch flat brush to stroke highlights over the raised areas of each cobblestone. The more texture you add, the older the stones will look.

Marble

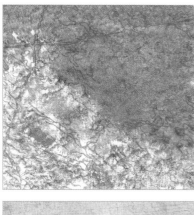

STEP ONE Marble features soft, mottled textures and stronger striations that cut across its surface. To achieve soft transitions, work wet-into-wet or blend with a very soft, dry brush—or use a combination of the two techniques. Use a thin, milky gray mixture of black and white to stipple your surface with an old, worn round brush.

STEP TWO With the darker variations in place, build the whites of the marble. Create a semi-opaque glaze by thinning white and paint it over your entire surface using a large flat brush. Add as many layers as you desire, but let them dry between applications and avoid completely covering the grays below.

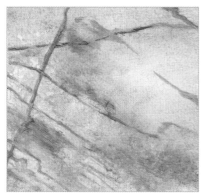

STEP THREE Now that you have created the luminous, transparent whites over the darker variations, add some of the darker veins that run through the marble. Use a long striper brush and a thin black glaze to paint long, thin lines diagonally across the surface. Use a soft, dry brush to softly blend and integrate them with the previous layers.

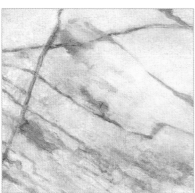

STEP FOUR Finally, once your painting dries, evaluate your texture. Determine whether you want to bring up the value of any of the whites and add layers where needed. Also, if any gray details are too strong, simply glaze over them with a thin layer of white. The more layers you add, the more depth the marble will have.

56 Pearl

STEP ONE The most unique qualities of pearls are their iridescent, swirling colors. First establish a cool, semi-transparent underpainting of reddish purple mixed with equal parts of black, alizarin crimson, and white. Thin this color and use a ½-inch flat brush to create long curves that follow the form. Add more white for lighter values, and blend everything softly at this stage.

STEP TWO Pearls reflect many different colors, including pinks, blues, golds, and many variations of white. Begin with a soft ½-inch flat brush and mass in the primary base colors of salmon pink using blends of Venetian red and yellow ochre lightened with small amounts of white. Then create the more purple sections by mixing ultramarine blue with small amounts of Venetian red and white. Thin the paint so you can create long, smooth, sweeping strokes that follow the curves of the pattern found in your reference.

STEP THREE Pearls are basically white with other soft pastel colors reflected onto their semi-translucent surfaces. Mix various lighter values of pink and purple with mixtures of white tinted with yellow ochre, cobalt blue, or alizarin crimson; then add these where the light is strongest. Enhance the subtle pattern that swirls around the natural variations in the pearl surface.

STEP FOUR Once everything dries, focus on adding the brightest highlights. Add more white to your mixtures and, with a #2 round brush, accentuate the lines and nodules that are receiving the most light.

Diamond

STEP ONE Diamonds come in many different types of cuts, but all of them reflect various colors from their surroundings. Always include colors from the environment in your diamond surfaces to integrate them with the other elements of the composition. After carefully drawing the multifaceted surface, start by painting the darkest facets with cool purple-grays mixed with various blends of black, alizarin crimson, ultramarine blue, and white. Thin your colors to create semi-glazes that you can easily control with a #4 round brush. Eliminate your brushmarks using a small, soft, dry brush.

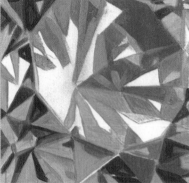

STEP TWO With variations of blue and purple-grays, continue to carefully paint the triangles that make up the individual facets of the diamond with a small #2 round brush. Mix any other colors that may be reflecting onto them from surrounding objects or light sources. Remember to keep the top face of the diamond lightest and clearest, with darker shadows around the edges.

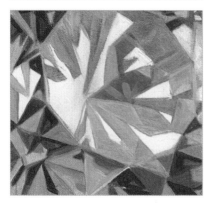

STEP THREE In this step, continue to fill in the various facets with whatever colors you desire. If the darks on the face of the diamond compete with those on the receding sides, tone them down with a light bluish-white mixed from cobalt blue and white. Continue using a small #2 round brush.

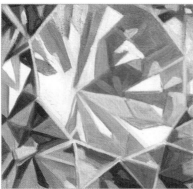

STEP FOUR For the final details, load a long striper brush loaded with pure white that has been thinned slightly for flow. Clean up the edges of each facet by adding a fine highlight line between each section. This will integrate the facets to create the illusion of one diamond, rather than a collection of individual cuts.

58 | Smooth Wood

STEP ONE You can quickly capture the texture and grain of smooth wood using a ½-inch flat brush and layers of semi-glazes. Start with a mixture of equal parts of burnt sienna and yellow ochre, thinning it to a milky consistency so that it flows smoothly across your surface. Work side to side with soft, horizontal lines that mimic the curves of the wood grain. Paint one stripe at a time, but be sure to overlap your bands to create the soft edges that result from painting wet-into-wet.

STEP TWO Now build the lighter middle values of the wood using a mixture of equal parts of yellow ochre and burnt sienna, lightened with a touch of white. Hold your ½-inch flat brush by the very end of the handle to keep your marks loose and spontaneous. Sweep from side to side in consecutive, curving bands that simulate the pattern of wood. Work from top to bottom, with each row responding to the previous row. Thin your paint to help it glide smoothly across your surface.

STEP THREE After the paint dries, use the same ½-inch flat and a mixture of equal parts of burnt sienna, yellow ochre, and white to add lighter details to the wood pattern.

STEP FOUR In this final step, lighten areas of the wood grain—especially if you are working on a light-colored wood, such as light oak. Simply add more white and yellow ochre to your previous mixture and thin the paint. Use your ½-inch flat brush to stroke over the highest parts of the grain with a layer of color, punching up the highlights.

Aged Wood

STEP ONE The texture and neutral color variations of aged wood call for a loose, impressionistic style. Lay in the underpainting and dark horizontal bands with a ½-inch flat brush and a thin mixture of equal parts of black and burnt sienna. Work from side to side in long, continuous strokes, allowing the brushmarks to suggest the natural wood grain.

STEP TWO Next build up the base colors with texture using the edge of a ¼-inch flat brush. Mix equal parts of ultramarine blue, black, and white for the cool gray areas of the wood, and mix burnt sienna with yellow ochre for the warmer, lighter areas. Work from side to side in choppy, horizontal strokes.

STEP THREE After the paint dries on your canvas, add more white or yellow ochre to the mixture from step two and continue to paint the lighter areas with short, organic strokes from one side to the other. Keep your strokes coarse and broken to let the darker colors beneath show through.

STEP FOUR The most important details of your aged wood are the highlights found along the top edge of each plank. Add these highlights carefully using a fine #2 round brush and a thin mix of equal parts of white and yellow ochre.

60 Wooden Barrel

STEP ONE When painting a wooden barrel, begin painting the wood first and the metal banding second; this ensures that your wood grain flows realistically from one side of the banding to the other. Begin building the middle values of the wood by creating a thin mix of burnt sienna and black. Rotate your surface so you can stroke from side to side, and use a ½-inch flat brush to loosely lay down a layer of glaze. Carefully maintain the perspective by keeping your curved brushstrokes parallel to one another.

STEP TWO Next add light grays and browns over the aged wood using various mixtures of black, white, and burnt sienna. Use the thin edge of your ½-inch flat brush to work in horizontal stripes, adding lighter grays along the top and gradating to warmer middle values of brown as the barrel curves downward. You can paint right through the steel band areas so the wood grain flows consistently from one section to the next.

STEP THREE Next load a #2 round brush with a thin mix of burnt sienna and a bit of black, and draw thin, curved shadows behind each metal band. Add white to this mix and switch to a ¼-inch flat brush to paint the top surface of each band, stroking from top to bottom. For the light values of wood, add more white and burnt sienna and work in horizontal stripes that follow the grain of the wood. Avoid overlapping the bands.

STEP FOUR Add a few color accents to the metal bands by drybrushing with raw sienna. Then use the tip of a #2 round brush to carefully stroke in the separations between the planks of wood with a dark mix of burnt sienna and black. Next use a ½-inch flat brush to drybrush more light values over the wood, stroking along the grain and avoiding the metal bands. Finally, use various light mixtures of white and burnt sienna to add highlights below the plank separations and along the edges of the metal bands.

61 Wrought Iron

STEP ONE Although wrought iron is black or dark gray, make it more interesting by adding a little color from the surrounding environment. This will help you integrate the colors in your painting for a sense of color unity. Begin by using a ½-inch flat brush to lay in a middle-value gray wash of thinned black.

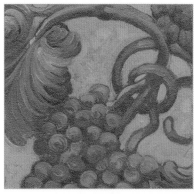

STEP TWO Next paint the darkest gray areas of the wrought iron with a #4 round brush and a mixture of black and small amounts of burnt sienna, lightened with a touch of white. Build as much texture as you'd like.

STEP THREE With the darkest grays complete, add small amounts of white to the mix to create various lighter grays. Use a #4 round brush to fill in the rest of the iron, paying close attention to the location of your light source and how the light hits the various forms of the wrought iron. Now clean your brush and create various mixtures of sap green, white, and a bit of black for the neutral green background. Keep your strokes loose and impressionistic to keep the viewer's focus on the detail of the iron.

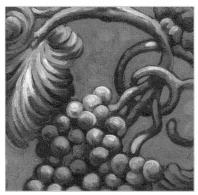

STEP FOUR Now add the final lights and highlights to the wrought iron using a #2 round brush and mixes of white and black. Include trace amounts of sap green and burnt sienna in your gray mixes to unify the painting and give life to the wrought iron.

FOOD & BEVERAGE

COLOR PALETTE

• alizarin crimson • burnt sienna • cadmium orange
• cadmium red light • cadmium yellow light
• dioxazine purple • green-gold hue • ivory black
• raw sienna • sap green • titanium white
• Venetian red • yellow ochre

62 Citrus Fruit Rind

STEP ONE To begin building the dimpled texture of an orange rind, create a thin mixture of equal parts of burnt sienna, cadmium red light, and cadmium yellow light. Use a ½-inch flat brush and dab in the color to create an irregular, dappled texture. Add a touch more burnt sienna for the darker areas.

STEP TWO Using various mixtures of cadmium red light and cadmium orange darkened with sap green, apply the basic middle and shadow values of the orange. Use the corner of a ½-inch flat brush turned on its edge to create short, impressionistic strokes that resemble the mottled texture of an orange rind.

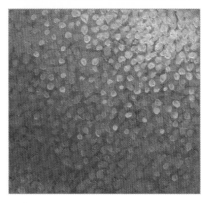

STEP THREE After your previous layer has dried, switch to a #6 round brush to finish developing the texture with small dabs of lighter colors, again working from dark to light. If the colors blend together too much, allow the paint to dry before moving on to your lightest highlights. Use small amounts of thin cadmium orange and cadmium yellow light for your highlights. Reload your brush often to create clean spots of color.

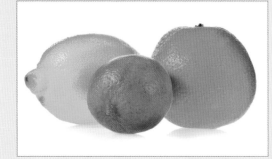

TIP

You can use this texture for all dimpled citrus rinds, from lemons and limes to oranges and grapefruits! Simply adjust the colors to match your chosen fruit.

63 Orange Fruit

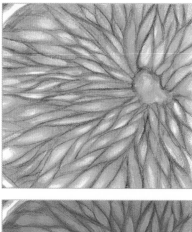

STEP ONE The most interesting parts of an orange slice are the smooth, shiny teardrop-shaped pieces that weave together and fan out from the center. To "draw" this pattern, use a #7 round brush loaded with a mixture of equal parts of cadmium orange, cadmium yellow light, and sap green, thinned for a smoother line. Working from the center outward, retrace your lines to knock down the brushmarks and blend to achieve soft gradations.

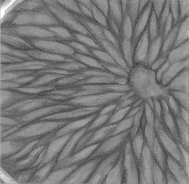

STEP TWO After the paint dries, thin cadmium orange to create a transparent glaze. Use a ½- flat brush to paint an even layer of color over the entire interior of the orange, lightly working the surface to blend and remove all brushstrokes. Next, add equal parts of cadmium yellow light and white to your glaze mixture and use a #4 round brush to paint lights over each individual section. Move from the center outward, leaving thicker brushstrokes that will catch the light.

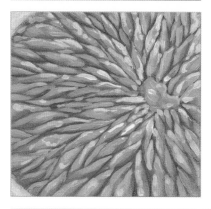

STEP THREE In this final stage, add the lightest values and highlights to give the orange its juicy appearance. Thin equal parts of cadmium orange, white, and cadmium yellow light; then use a small #2 round brush to paint single brushstrokes lengthwise over each section. Allow the paint to remain thick, which will catch the light and give the impression of a wet surface. After this layer dries, add small amounts of cadmium yellow light to white and dab on the final highlights.

TIP
When painting moist textures, consider enhancing them with a layer of gloss medium.

Apple

STEP ONE To create this luscious red apple, start with an underpainting of the darkest shadow color. Using a ¾-inch flat brush, apply a solid layer of two parts alizarin crimson to one part black, thinned slightly for flow. Pull out some color in the highlight areas and background to establish the general form.

STEP TWO Next build the middle values with a mix of equal parts of Venetian red and cadmium red light. Use a ¾-inch flat brush to make long strokes, curving downward from the top rim to the lower third of the apple. Even without variation in color, the curve of these brushstrokes will begin to define the form.

STEP THREE To begin building the lighter red values on the top third of the apple, mix equal parts of Venetian red with cadmium red light, adding a bit of white to lighten. Use a ¼-inch flat brush to work in short, impressionistic strokes from top to bottom, following the natural contour of the apple to create a convincing form.

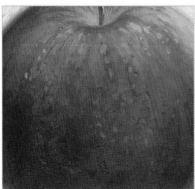

STEP FOUR Finally, add more white to your mixture and apply the lightest colors around the rim of the apple. Stroke down toward the center using a ¼-inch flat brush and short, impressionistic strokes, giving the surface texture and variation without completely covering the base colors. This will add depth to your surface. Mix equal parts of cadmium yellow light, sap green, and white, and use a #3 round brush to add the lighter areas along the stem and the spots on the apple's skin. You can use your finger or a soft, dry brush to soften these spots.

65 **Grapes**

STEP ONE The most distinguishing characteristics of red grapes are the deep, reddish purples and chalky, bluish whites that cover the surface. To begin, establish the rich red undertones and shadows with a glaze made from a thin mix of equal parts of alizarin crimson and dioxazine purple. Use a ½-inch flat brush to apply color loosely around the contour of the grapes and into the shadows. Add a little white to your mixture to increase its opacity and cool the purple, creating an effective transition between the deep reds and lighter blues.

STEP TWO After this initial layer dries, continue building the rich red purples of the grapes with a thin mixture of equal parts of alizarin crimson and ultramarine blue darkened with small amounts of black. Use the corner of a 1-inch flat brush to stipple on the color and create a spotty texture. Work wet-into-wet for a softer effect.

STEP THREE Let the glazes dry completely. With the transparent layers of the grapes in place, it's time to start working on the bluer, more opaque areas found on the surfaces in the light. For this color, use a mixture of three parts white, one part alizarin crimson, and one part black or ultramarine blue. Load a ¼-inch flat brush and wipe off the excess paint from your brush, working from the lighter areas and moving toward the shadows as the amount of paint on your brush diminishes. Keep your marks loose and impressionistic rather than smooth and over-rendered, but avoid obvious brushmarks.

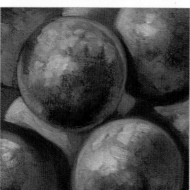

STEP FOUR To create the bluish-white highlights on the grapes, mix small amounts of ultramarine blue and alizarin crimson with white. Load a ¼-inch flat brush and wipe off any excess paint, and then add short, impressionistic strokes along the tops and right sides of each grape. As the paint on your brush decreases, lightly work a little color onto the bottom and left shadow sides to create reflective light. This will make your grapes look more three-dimensional.

Coconut

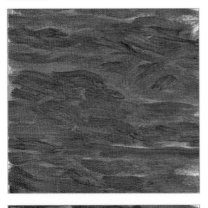

STEP ONE The exterior of a coconut shell features a variety of textures that you can achieve with a very loose approach. Start with a thin underpainting of equal parts of burnt sienna and sap green. With a ½-inch flat brush, lay in a loose layer of color and let your brushstrokes show. Work from side to side along the natural curve of the coconut.

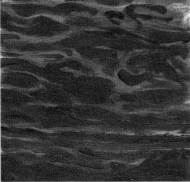

STEP TWO In the next layer, continue modeling the form of the coconut, making it darker at the bottom and lighter at the top. Use a #6 round brush loaded with equal amounts of burnt sienna and sap green, thinned a bit for flow. Following the contour of the coconut, use loose, squiggly strokes that serve as a great base for the hairy texture you will add in the following steps.

STEP THREE Now create the hairy fibers of the coconut shell. Work from dark to light and mix variations of sap green, cadmium orange, yellow ochre, and white. Use a #4 round brush to dab on thick spots of color in the lighter areas. Use a fine-pointed palette knife to scratch into the paint, spreading and dragging the paint to create hairlike fibers. For this technique, it's a good idea to experiment first on another painting surface.

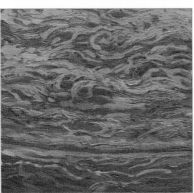

STEP FOUR After the previous layer dries, add more white and yellow ochre to your mixtures for the lightest details, and use a #4 round brush to loosely lay in the color. Then use your palette knife to scratch into the paint and create the fine strands of the coconut texture.

67 Peanut Shell

STEP ONE To achieve the warm, golden brown found in the shadows of these peanut shells, create a thin mix of equal parts of burnt sienna and green gold. Brushing lengthwise along the peanut forms, build up the shadow areas while keeping your brushmarks soft and noncommittal. This will help your edges recede and suggest more depth in your final image.

STEP TWO Mass in the middle values of the peanut shell using burnt sienna mixed with small amounts of black for darker areas and white for lighter areas. With a ¼-inch flat brush, paint short, impressionistic strokes lengthwise along the shell forms, following their natural curves. Allow some of your underpainting to show through.

STEP THREE To build the lighter areas and pattern of the shell, add yellow ochre and more white to your mix and carefully highlight the raised parts of the pattern that catch the light. The details do not need to be exact; simply study and capture the curves and character of the ridges. Wipe off the excess paint from your brush to keep the edges of your brushmarks soft, allowing them to blend with the darker values.

STEP FOUR In this last stage, render the finest details and add the highlights. Mix one part yellow ochre to two parts white and load a ⅛-inch flat brush. Then use the drybrush technique to highlight the gridlike pattern of the shell. As the paint diminishes on your brush, add softer details to the shadows for interest.

Walnut Shell

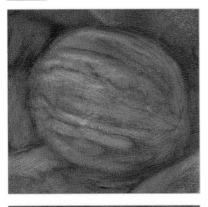

STEP ONE To begin building the texture of walnut shells, start with a warm, dark brown made up of one part burnt sienna to two parts sap green. These transparent paint colors are perfect for underpaintings because they allow your drawing to show through. Apply a flat layer of color with a ½-inch flat brush and pick out color on the lighter areas with a cotton swab or a soft cloth rolled into a point.

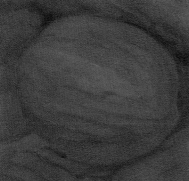

STEP TWO Using a ¼-inch flat brush, mass in the basic brown values for the walnut shells with a mixture of equal of parts of burnt sienna and black, adding small amounts of white or yellow ochre as you move onto the lighter areas. Work lengthwise along the shell pattern in short, impressionistic strokes.

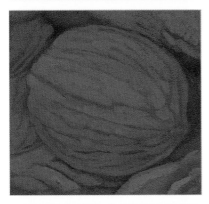

STEP THREE After the middle values dry, lighten the mix from step two with a small amount of white. Load a ¼-inch flat brush or #6 round brush, wipe off the excess paint, and use the dry-brush technique to define the lightest sections. The more texture you pick up from the painting surface, the more it will resemble an authentic walnut shell.

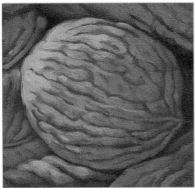

STEP FOUR Now it's time to add highlights to capture the details of your shell. With a mixture of one part raw sienna to two parts white, use a ⅛- or ¼-inch flat brush to drybrush color onto the raised areas of the shell, carefully avoiding the veinlike lines between them. Study an actual walnut to understand how the various sections of the shell merge in and out of each other.

69 **White Wine**

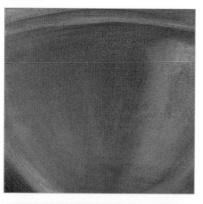

STEP ONE Although white wine is light gold in color, begin by establishing the cooler, neutral pink undertones by mixing equal parts of burnt sienna and black with white to brighten. Thin this mixture and use a ½-inch flat brush to apply an even layer of color. Then use a soft cloth to pick out color on the glass along the rim (where the primary light hits) and bottom edge (where the reflected light hits).

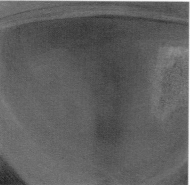

STEP TWO While it may be a challenge to create the transparent look of liquid with oil or acrylic paint, you can create a convincing representation using glazes and careful transitions of color and temperature. In this step, create a base for applying brighter, more saturated colors later. Using a ½-inch flat brush, build on the central shadow with a thin mix of equal parts of yellow ochre and raw sienna. Add a touch of white as you move to the lighter left side of the glass, and add ultramarine blue to create the cooler, bluer reflected light along the outer edges of the glass.

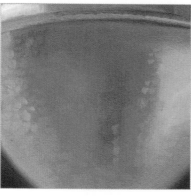

STEP THREE After the paint has dried, build up the lighter, warmer areas with a mix of one part raw sienna, one part yellow ochre, and two parts white. Wipe off excess paint from your ½-inch flat brush and then drybrush areas of the wine where the light is strongest. Use the corner of your brush to dab on spots of color to create the impression of reflections and condensation on the glass.

STEP FOUR Allow the paint to dry and then brighten the light coming through the golden wine with a ¼-inch flat brush and a mixture of equal parts of white and yellow ochre. Apply small dabs of color between the lights and shadows to suggest more condensation.

Red Wine

STEP ONE The secret to painting red wine—or any liquid—is to build up depth of color through glazes. Apply the glazes in several layers, allowing each to dry before adding the next. To create the base layer for red wine, mix alizarin crimson with small amounts of cadmium red light (for warmth) and black (to darken). Lay in a smooth layer of color and eliminate all brushmarks with a soft, dry brush. Clean your ½-inch flat brush and pat it dry on a cloth. Then use this brush to scumble over the lightest areas of your image, loosening up the glaze and removing it with the hairs of the brush. Wipe your brush and continue to pick out color as needed.

STEP TWO After your first layers dry completely, continue to build your dark, rich reds with another layer of glaze mixed from thinned alizarin crimson and a touch of black. Use a ¼-inch flat brush to trace over your brushmarks, blending and softening transitions. You can also use a separate soft, dry brush to sweep lightly over the glaze.

STEP THREE By adding alizarin crimson and cadmium red light to your mix in small amounts, you can build up the lighter values reflected in the wine and on the glass. Choose your brush size depending on the size of the details you are working on. Blur the transitions between the whites and reds by wiping off your round brush on a cloth and dragging the hairs along the edges of your colors. Repeat as necessary to achieve smooth blends.

STEP FOUR In this final stage, brighten the white areas. Add a little cadmium red light to your white and apply the small details along the ridges of the wine. Using a ¼-inch flat brush, drybrush the soft transitions from white into the deeper red wine color at the center of the glass.

71 Black Coffee

STEP ONE Black coffee isn't really black, but it's close! Begin building the smooth, dark color using a few layers of a rich, dark brown mixed from one part burnt sienna to three parts black. Use a ½-inch flat brush loaded with a generous amount of paint to cover the darkest areas. Blend the edges with a ¼-inch flat brush before they dry.

STEP TWO Mix equal parts of burnt sienna and white, dulling the mixture down with a touch of black. This will create the reddish-gray middle value in the reflection of the black coffee. Paint a smooth layer of color using a ¼- or ½-inch flat brush.

STEP THREE Now add more white to the mixture from step two and apply another layer of opaque light brown to the reflection using your ¼-inch flat brush. Focus on building up the areas around the bubbles.

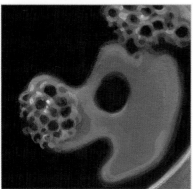

STEP FOUR While the black coffee itself may not be complex, the bubbles are really what give the coffee interest and diversity. Mix white with a very small amount of burnt sienna, and use a #2 round brush to refine the white rings of the bubbles, tracing over your lines to soften their edges and blend them into the darker colors beneath.

French Baguette

STEP ONE The appetizing golden brown and contrasting textures of a baguette make it beautiful and interesting. Mix equal parts of burnt sienna and sap green for the middle values, laying down a quick and loose layer with a ½-inch flat brush. Add more layers of this transparent mix over the darkest areas to begin modeling the form of the bread.

STEP TWO Mix two parts of burnt sienna and one part yellow ochre with small amounts of black to darken or white to brighten. Use a ½- or ¼-inch flat brush to add the golden middle values on the sides and in the shadows of the crusty top. Quick, short, painterly brushstrokes will help you loosely suggest the cylindrical form of the baguette.

STEP THREE Continue to build up the middle values, especially on the top and along the main ridge of crust. Use the same colors from step two, but add yellow ochre and white to warm and brighten the mix. You can use the corners and flat edge of a ¼-inch flat brush to create small, impressionistic marks for the bumpy crust.

STEP FOUR The final crust detail gives the baguette its distinctive appearance. With a light mix of white and yellow ochre, use a #4 round or ¼-inch flat brush to paint the ridges of crust where the bread splits and spreads using loose, organic brushstrokes. Hold your brush at the very end of the handle for more natural and varied gestures.

73 Frosting

STEP ONE Capturing the look of creamy frosting is all about the curves and lusciousness of your paint. While the initial layers may be thin to establish the transparent shadows, you can build the subsequent layers with a palette knife and impasto strokes—just like frosting a real cake! Begin by laying in the shadows with a mixture of one part alizarin crimson to two parts white, warming up the mix with a touch of yellow ochre. Use a ½-inch flat brush to paint the darkest areas with long, curving strokes.

STEP TWO Switch to a ¼-inch flat brush and add warm purples to the shadows using equal parts of alizarin crimson and cadmium red light brightened with a small amount of white. Apply these warmer colors on the shadowed sides of the frosting ridges. To create the cooler bluish purples in the shadows, add ultramarine blue and white and stroke along the ridges.

STEP THREE Continue to build up your values with lighter pinks and purples using your ¼-inch flat brush. Apply the paint on the sides and over the top plane of the cake using thick, swirling strokes. After these layers dry, use a small round-edged palette knife loaded with three parts white to one part cadmium red light to frost the top of your cake with impasto strokes.

TIP

To match the consistency of frosting, consider adding body to your paint with modeling or molding paste. This additive can help you achieve thick impasto strokes with stiff peaks, giving your painting extra dimension and depth.

Dark Chocolate

STEP ONE The browns in a square of dark chocolate vary depending on the angle of the light. However, in general, dark chocolate reflects a cool, blue light that yields warm shadows. Start with a warm, medium-value brown mixed with equal parts of burnt sienna and black. With a ½-inch flat brush, cover the chocolate with an even layer of color; then quickly brush over the darker sections with another layer before the first layer gets sticky. Use a soft, dry fan brush to remove all the brushmarks.

STEP TWO Continue painting the middle values of the chocolate with equal parts of burnt sienna and black, lightened with varying amounts of white. The different planes of the chocolate reflect the light differently, shifting the values from surface to surface. Depending on the width of the section, use a ½-inch or ¼-inch flat brush in long, smooth strokes. Remove any obvious brushmarks or sharp edges between sections by stroking over your canvas several times, softening the transition between planes.

STEP THREE The lightest areas of dark chocolate tend to be cool, bluish browns that stand in contrast to the dark, rich, warm browns of the shadows. Add more white and black to the mixtures to create cooler browns; use a ¼-inch flat brush to stroke this color where the light is strongest on the chocolate.

STEP FOUR With the dark and middle values of the chocolate in place, paint the light, cool white reflected on the tops and light sides of the squares. Use a mixture of three parts white, one part black, and one part burnt sienna. Depending on the level of detail you want to achieve, alternate between a #4 round and a ¼-inch flat brush. Consider using a maulstick (a long stick to steady your hand), or simply rest your forearm on your other hand as you paint.

NATURE

COLOR PALETTE

• alizarin crimson • burnt sienna • cadmium orange
• cadmium yellow light • cobalt blue • ivory black
• manganese blue hue • Payne's gray • phthalo blue
• raw sienna • sap green • titanium white
• ultramarine blue • Venetian red • yellow ochre

Tree Bark

STEP ONE Whether you're painting tree bark or mountain rocks, it's best to start with a warm, dark underpainting in the manner of the Masters. This will quickly establish a middle tone that you can build upon. It will also help you control the variety of hard and soft edges that create depth and variety in a painting. For this underpainting, use burnt sienna darkened with a small amount of black. Pounce out the brushstrokes to even out the color without lifting it off your support, which will allow your drawing to show through the underpainting.

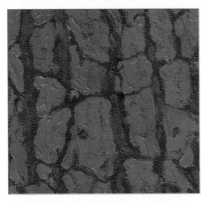

STEP TWO Continue to build your underpainting by adding the dark shadows between the raised areas of the bark. Create a mix of three parts burnt sienna to one part black, thinned slightly for flow. Use a ¼-inch flat brush to apply the paint, holding the brush at the end of the handle to create loose, spontaneous marks that are indicative of nature's organic shapes and forms.

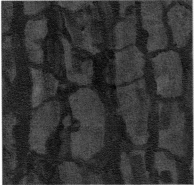

STEP THREE Next build up the main thick parts of the bark using a small, triangular palette knife with a narrow but rounded tip. This will give you a good amount of control while allowing you to create variety of shapes on the bark surface. Add white to your previous mix to create various cooler browns and reddish grays, and carefully place thick color onto the raised surfaces of the bark. Work from the edges toward the centers of each area.

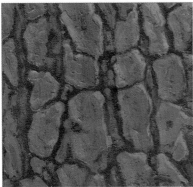

STEP FOUR To add the final details to the edges of the bark, indicate the areas where the light is strongest. Mix more white into your previous mixtures and use a #2 round brush to loosely add touches of color on the edges and tops of the raised sections. Add a few strokes within the dark grooves as well.

76 Pine Tree Needles

STEP ONE Because the branches of a pine tree are so intricate, aim to capture the general look of needles while reserving the finest detail for the closest elements. An old, stiff brush with splayed bristles might be the best choice for this, but experiment with what is available to you. Begin by creating a soft background that simply alludes to branches and needles using a thin mix of sap green warmed with small amounts of burnt sienna. Use the edge of a ½-inch flat brush to create short, parallel strokes along each branch, giving the impression of needles.

STEP TWO Before you actually paint the needles, build up the shadow details. This will save you time and keep your background from appearing too complex, which will help it recede. Use the same stiff ¼-inch flat brush and sap green darkened with small amounts of black. Continue stroking in the direction of needle growth.

STEP THREE After these darker layers dry, begin to build the details of the background. For the dark, cool green of pine needles, mix sap green with small amounts of white and black. Use the corner of a ¼-inch flat brush to apply rounded brushmarks that look like bundles of pine needles from a distance. For the brown branches that peek through the needles, add yellow to your mixture and thin it until the paint flows smoothly. Use a #2 round brush to render individual needles on the foreground branches.

STEP FOUR Before you add final details to the foreground, create a light, cool green with sap green and small amounts of white and black. Using your ¼-inch flat brush, apply this color to lighten some of the branches in the background to suggest more dimension and depth. Finally, add more white to the mix and thin it down; then use your #2 round brush to carefully render the individual needles on the foreground branches.

Pinecone

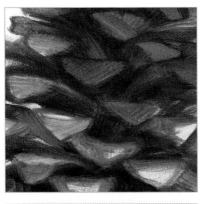

STEP ONE For the dark, semi-transparent neutral purple in the shadows, mix equal parts of black and alizarin crimson, lightened with a touch of white and thinned down to a semi-glaze. Use a ¼-inch or ½-inch flat brush and work from the center of each section toward the triangular knob at the end, keeping your brushstrokes loose and soft as you get a feel for the shapes. You can start with very thin color and build up value in layers, but be sure to let your painting dry between each layer.

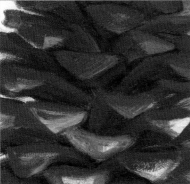

STEP TWO Add color to your shadows with a ¼-inch flat brush. Use purples mixed with ultramarine blue, alizarin crimson, and small amounts of white for the darkest areas along the stalks and under the knobs. Use raw sienna along lighter areas of the stalks and knobs.

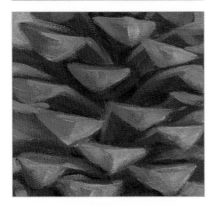

STEP THREE Now add the lightest areas to the knobs. Mix equal parts of white and yellow ochre plus a small amount of phthalo blue for a slightly green cast. Use a #4 round brush to carefully add this color to the front right side of each knob.

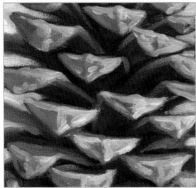

STEP FOUR To give your pinecone the depth that makes its shapes so interesting, use a #2 round brush to add the final highlights on the fronts and edges of each knob and stalk. Keep your marks painterly to capture the variations in the natural surface texture of the pinecone.

78 **Palm Frond**

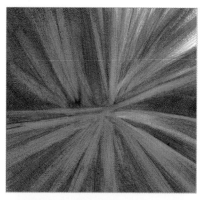

STEP ONE The most interesting aspects of palm fronds are the play of light on the individual leaves and negative spaces that occur between the leaves. It's important to emphasize both features in your work. Palm fronds have such a distinctive shape that you don't need to paint every single leaf to capture its character. Start with a thin underpainting of transparent green mixed with sap green and a touch of burnt sienna, which will establish the surrounding vegetation and a base color for brighter greens. Pounce out all the brushstrokes and pick out color in the lightest areas to establish the way light is falling on the subject.

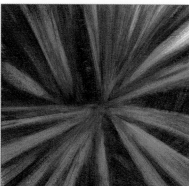

STEP TWO Finish painting your shadows and adding interest to the background with a darker, cooler layer of sap green mixed with small amounts of black. Use a ¼-inch flat brush as you stroke long lines and fill in larger areas. Retrace your marks to keep the edges flat and soft.

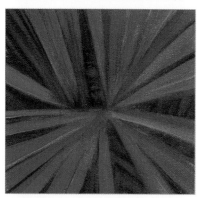

STEP THREE Now you are ready to paint the basic green values of the palm leaves. Add two parts cadmium yellow light to three parts sap green; then use the same ¼-inch flat brush to work in long, continuous strokes from the ends of the leaves toward the darker center. Decrease pressure and rotate your brush as you near the center to narrow your stroke and blend the color into the shadows.

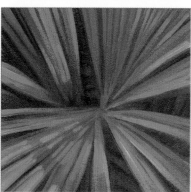

STEP FOUR Finally, it's time to add the bright yellow greens that give palm fronds their drama. Not only does light hit the top surfaces of the leaves to create interesting cast shadows, but light also shows through them due to their translucency. Add more white and yellow to your mixture and thin it for flow. Then use a #2 round brush to add the highlights, working from the tips of the leaves toward the center.

Thatched Roof

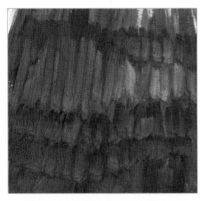

STEP ONE When creating the texture of a thatched roof, it is easiest to start with dark, blurred shadows and build on them with lighter values. This helps shadow edges recede and keeps them soft so they don't compete with the details in subsequent layers. Start by mixing burnt sienna with a small amount of sap green. Holding a ½-inch flat brush vertically, paint edgewise in loose, vertical strokes. After you have covered the surface, add more sap green to create a darker value and cut in short, vertical shadows that run horizontally across the roof. This creates the look of layered sections of hay.

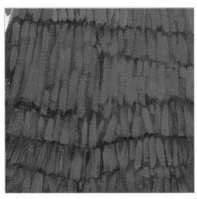

STEP TWO With the warm, dark shadows in place, work on the straw itself. Begin in the shadows by adding cool, grayish golds with a mixture of equal parts of yellow ochre, white, and black. Use the corner and width of a ¼-inch flat brush to paint in vertical sections with various widths, starting from the top and working down toward the end of each section.

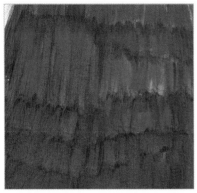

STEP THREE Allow this darker, cooler layer of color to dry. Then switch to a #4 round brush and rotate your support so that you can stroke comfortably from the ends of the straw upward. Create a mixture of equal parts of white and yellow ochre plus a small amount of burnt sienna; then thin the mixture to create smooth, clean vertical marks along the layers of thatch.

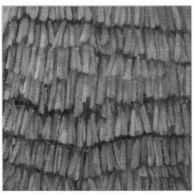

STEP FOUR In this final step, enhance the light on the thatch that is closest to your light source—or simply add light to areas that need more dimension and variety. With a #2 round brush, add thinner lines along the edges of these sections with a mix of equal parts of white and yellow ochre. Do not overdo this stage, but rather use these highlights sparingly for a realistic look.

Fern

STEP ONE Ferns have very busy leaves, so it's best to reserve your finest details for a few well-placed ferns in the foreground of your composition. Keep the detail to a minimum in the shadows and distance while alluding to the unique character of the plant. Work from back to front so you don't have to paint around complex foreground shapes. Begin by loading a ½-inch flat brush with a dark, transparent mix of sap green warmed with a small amount of burnt sienna. Apply short, impressionistic strokes in various directions as if you are painting the shapes of fern leaves. They should blend together with soft edges and cover your background.

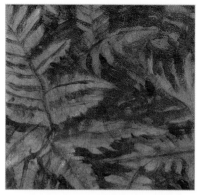

STEP TWO After your underpainting dries, switch to a smaller #4 round brush and add another layer of darker greens to the shadow areas behind and between the foreground ferns, while building fernlike shapes in the negative spaces. Keep these areas simple and more suggestive than realistic so they recede and don't compete with the more detailed leaves in the foreground.

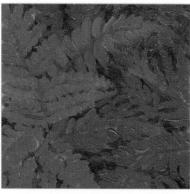

STEP THREE After the previous layers dry, use a #4 round brush to add more detail in the background. Lighten sap green (or any dark, cool green) with small amounts of cadmium yellow light and apply small strokes that start at the tip of each leaf and end at the stem. Reload your brush before applying each leaf for clean, consistent marks. If your color seems too strong, simply add a touch of black to neutralize and darken. For the foreground ferns, add more yellow and a touch of white.

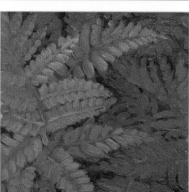

STEP FOUR In this final step, simply repeat step three using brighter greens mixed with more yellow and white. You might also switch to a #2 round brush for added control. Begin in the background and brighten your greens as you move forward, working on the closest branch last.

81 Moss

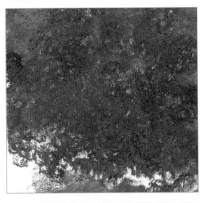

STEP ONE When painting moss, it's important to work on the moss and the surface beneath (such as rock) at the same time so they integrate well with one another. Start painting the rock with a wash of black lightened with a small amount of white. Use a ¼-inch flat brush to build texture with short, impressionistic strokes or a loose, stippled texture. Clean your brush and mix the warm shadow green of the moss with equal parts of sap green and burnt sienna. Dab your ¼-inch flat brush into the paint and onto your surface, using the stippling of your brush to create a mosslike texture that blends into the gray of the rock.

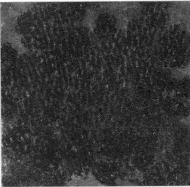

STEP TWO After your underpainting dries, continue to build the shadow color of the moss using a mixture of equal parts of sap green and yellow ochre. Experiment with different brushes, but look for one that will create small, organic marks that simulate moss texture as you stipple your paint. Old, small, stiff, and splayed brushes often work well for this purpose.

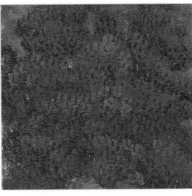

STEP THREE Allow your shadow layer to dry. Use the same brush to add lighter middle values of green to the higher parts of the moss with various mixtures of sap green brightened with small amounts of cadmium yellow light and white.

STEP FOUR For the final layer, add the lightest sections of the moss where the growth is newer and closer to your light source. Continue to add more yellow and white to your mixture and, for more control, use a #2 round brush to carefully add tiny strokes where needed.

82 Grass Field

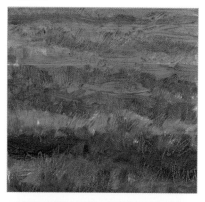

STEP ONE When painting a grassy field, use color tempera-ture and detail to suggest depth and atmosphere. Mix sap green with a small amount of burnt sienna, and use a ½-inch flat brush to lay in loose washes of color in horizontal sections. Use lighter, cooler colors and less detail in the distance, and use warmer, darker, and more textured brushmarks as you approach the foreground.

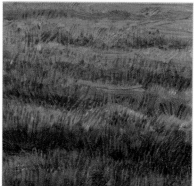

STEP TWO Switch to an old, stiff ¼-inch brush to add darker details in the shadow areas with a dark, cool green, such as sap green. Apply short grasslike marks made using a light touch.

STEP THREE Allow the paint to dry and start adding more specific grass details with a 1-inch long #2 striper brush, which is designed for linework. Use one part cadmium yellow light, one part white, and three parts sap green for the middle green. Hold the brush at the end of the handle to create loose, organic lines that start in the soil and move out in different directions. Your blades of grass should be shorter in the distance and longer in the foreground.

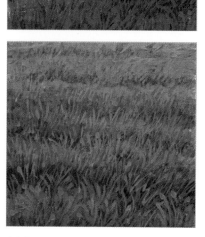

STEP FOUR To add the blades of grass that are hit by the most light, add more white and yellow to your mixture and thin it down until your strokes flow smoothly. Use your striper brush to paint long, curved blades in the lower half of your painting. Make sure the foreground holds the most detail and contrast. This will increase the sense of atmospheric perspective of your piece.

Flower Petals

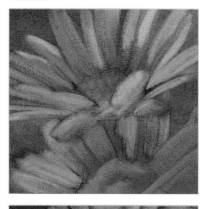

STEP ONE Start with an underpainting of sap green warmed with a small amount of burnt sienna; this will serve as the base color for the entire flower and add the illusion of greenery in the background without the need for much time or detail.

STEP TWO Next build the middle values of each area. Use the corner of a ¼-inch flat brush and short, impressionistic strokes to paint the shadows in the flower centers using cadmium orange darkened with a touch of sap green. For the background, stroke in a loose mix of sap green and cadmium orange, lightened a bit with white. Then mix one part ultramarine blue with three parts white and, using your ¼-inch flat brush, apply one long stroke from the tip of each individual petal toward the center. As you stroke, slowly reduce the pressure on the brush.

STEP THREE Continue lightening the petals with soft lavenders and pinks. Mix these colors using white tinted with small amounts of alizarin crimson and ultramarine blue. Use a ¼-inch flat brush and, starting at the tip, pull one clean brushstroke along each petal, lifting it off the support about two-thirds of the way to the center.

STEP FOUR Complete the flower by adding one final layer of thick, bright white on the petals where the light hits them most directly. Use a #2 round brush and focus on adding the striations that run the length of each petal. Start at the tip of the petal and let the white fade as you stroke toward the center. Then stipple a few cadmium yellow highlights over the flower centers to bring them to life.

84 Mountain Rock

STEP ONE When painting the texture of mountain rocks, remain loose and avoid over-working the details to ensure shape variety. Use a ½-inch flat brush to apply an underpainting of burnt sienna darkened with a small amount of black. This underpainting establishes the shadows with transparent color, which will recede against the lighter, more opaque colors applied in subsequent steps.

STEP TWO After your first layer dries, switch to a smaller ¼-inch flat brush to mass in the shadow sides of the rocks and add darker cracks. Use a mix of equal parts of yellow ochre and Venetian red, darkened with black. Your marks should follow the grain of the rock surface you are painting, which will help describe the form with less detail.

STEP THREE At this point, your painting will most likely look very dull and monochromatic. This is to be expected. In this step, you will add more contrast and texture on the top surfaces of the rocks where they receive the most light. You can use a ¼-inch flat brush or a palette knife for impasto strokes. Mixtures of yellow ochre and Venetian red darkened with black work well for the earthy reds of rocks found in the Southwest of the United States. Your brushstrokes should be short and impressionistic while following the grain of the rock.

STEP FOUR To clean up your edges, add more detail, and build a stronger sense of light in your composition, mix small amounts of yellow ochre and burnt sienna with white. Using a #4 round brush, add this lighter value where the light is strongest on the rocks. As a final touch, use a #2 round brush and a glaze of burnt sienna darkened with a black to add more cracks and clean up existing ones.

Smooth Rock

STEP ONE The key to creating realistic rock textures is to build layers of blended colors followed by cracks and highlights. Begin by painting the soft variations of color, starting with the darkest values. With a thin mix of black and small amounts of white and burnt sienna, use the tip of a ½-inch flat brush to stipple in a layer of subtle, mottled color.

STEP TWO For more subtle variations of color, use a smaller brush—such as a ¼-inch flat—and create less contrast between your color mixes. Work wet-into-wet as you stipple to achieve soft transitions.

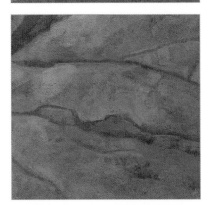

STEP THREE After your previous layers dry, add more white and yellow ochre to your mix and start building up the lighter areas of the stone. Now is also a good time to start cleaning up some of the edges along the cracks or simplifying areas that have become too complex or confusing. Drybrush your color onto the surface, allowing the colors beneath to show through.

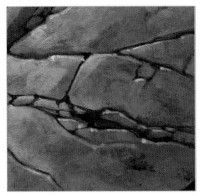

STEP FOUR Finally, using a #2 round brush loaded with a thinned mix of burnt sienna and a small amount of black, refine the darks and details of the smaller rocks and cracks. Then switch to white paint and add thin highlights along the top edges of the rocks and cracks, focusing on those that capture the light most directly.

River Pebbles

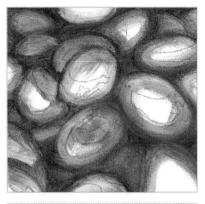

STEP ONE The two most important characteristics of river pebbles are their smooth, rounded edges and their glossy, reflective surfaces when wet. To create the soft, receding edges of the stones and their surrounding negative spaces, use a ¼-inch flat brush and a glaze of ultramarine blue neutralized with a small amount of burnt sienna. Redraw the stones and fill in the shadow areas, blending the color onto the surface of the stones as the amount of paint on your brush diminishes.

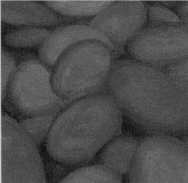

STEP TWO In this step, use a ¼-inch flat brush to establish the middle tones of the individual stones with yellow ochre, black, white, Venetian red, and ultramarine blue in various combinations. Work your brushmarks in circular movements that describe the roundness of the stones, and smooth out any rough strokes.

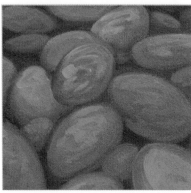

STEP THREE Next add small amounts of white to your various colors and thin them down to semi-transparent glazes. Continue adding dimension to your stones with loose brushstrokes on the upper portions of the pebbles that peek above the water. Keep your marks organic so they look like wet reflections on the smooth stones.

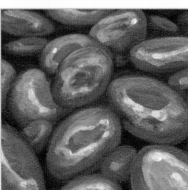

STEP FOUR In this final step, add light reflections that encircle the tops of the stones as they peek above the water's surface. Use a #2 round brush and a semi-glaze of white paint to loosely suggest the shapes of surrounding objects, such as trees, on top of each stone.

STEP ONE There are many ways to create the texture of sand, such as incorporating a textured medium or even using actual fine sand in your paint. However, you can create a convincing texture simply with paint, as in this example. Start with a base of middle-value brown mixed with three parts ultramarine blue, two parts raw sienna, and one part white. Use a ½-inch flat brush in long, curving strokes to create the soft ridges of this sand dune. Keep everything loose and non-committal at this stage so the shadows recede.

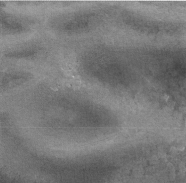

STEP TWO Switching to a ¼-inch flat brush, build up the texture of the sand by using the corner of your brush to stipple in slightly lighter variations of your color mixture. Work along the ridges of the sand and gently blend into the shadows as the paint diminishes on your brush. Let this layer dry before you start another.

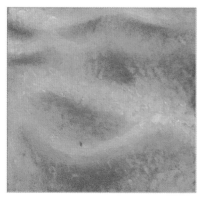

STEP THREE To build more texture and light in your image, mix white with small amounts of Venetian red and yellow ochre. Use your ¼-inch flat brush to brighten the dunes by stippling small dots of color along the ridges of the sand dunes; as the paint diminishes on your brush, scumble thin color into the shadows.

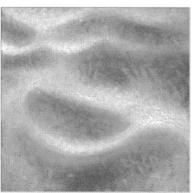

STEP FOUR To add the final highlights and add more specific texture to the peaks of the dunes, use an old, stiff #4 round brush. Consider cutting off the pointed tip of the hairs with a utility knife to give it a flat, circular end, which you can use to stipple thicker paint onto your painting. Add more white to your mixture from step three and dab it onto your painting wherever you'd like more light and texture.

88 Seashell

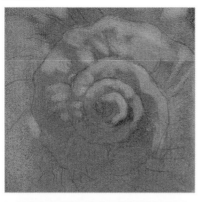

STEP ONE Seashells come in myriad colors, shapes, and patterns, so use this example as a guide for applying any color combination you wish. Begin the warm undertones of the shell with an underpainting of burnt sienna cooled down with a small amount of sap green. Use the pounce technique to eliminate any brushstrokes. Then pick out color from the lighter areas of the shell to indicate how the light falls across the form.

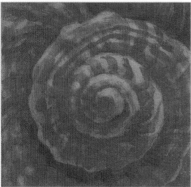

STEP TWO Next mix three parts Venetian red to one part ultramarine blue, lightened with a small amount of white. After studying the pattern of your shell carefully, establish the darkest parts first using a ¼-inch flat brush for the widest bands of color and a #4 round for more linear details, paying close attention to how the pattern follows the contours of the shell.

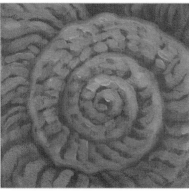

STEP THREE Now it is time to start building the lighter values of the seashell and adding detail to the pattern. With equal parts Venetian red, yellow ochre, and white, use your ¼-inch flat brush to paint single strokes that follow the contours of the shell, working between the darkest marks you added previously.

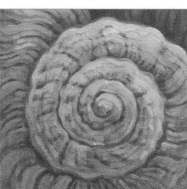

STEP FOUR To finish, build up the detail and brighten the values where the light is strongest. Add more white and a touch of yellow ochre to your mixture and, using a #4 round brush, work along the length of the shell and across its width to render the raised pattern.

Running River

STEP ONE The surface of water shows interesting patterns as it flows around and moves over rocks, branches, and other objects. To begin establishing these patterns, use a bluish gray mixed with two parts ultramarine blue to one part Payne's gray. Thin this with water (if using acrylics) or medium (if using oils), and use a ½-inch flat brush to loosely paint the shadows of the rocks and water.

STEP TWO To paint the middle values of the rocks and water, mix variations of ultramarine blue and white, darkening with black and warming with raw sienna. These neutral tones give the sense of vegetation and rocks under the surface of the running water. Use a ¼-inch flat brush to apply long strokes that follow the flow of the water.

STEP THREE Now begin building the bluish-white foam found around the rock, and continue weaving strokes through the water in the direction of flow. Use various mixtures of cobalt blue and white warmed with a touch of raw sienna. A small ⅛-inch flat brush or #2 round brush is a good choice for these long strokes.

STEP FOUR Once your previous layers dry, use a #2 round brush to enhance the lights in the water patterns with pure white paint. Hold your brush at the end of the handle to help you create looser, more natural marks that suggest the foam and water.

Still Lake

STEP ONE The most interesting aspects of a still lake are the reflections that fall on its surface. To create the reflections of the trees and foliage at the lake's edge, create a thin mix of three parts sap green to one part burnt sienna. Using a ½-inch or ¼-inch flat brush, work over the reflections from top to bottom and stroke in a subtle zigzag pattern to blur the details and create the illusion of water.

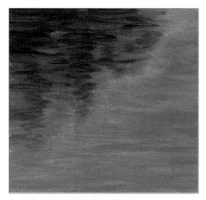

STEP TWO Next use a ½-inch flat brush to quickly paint the warm tones of the lake bottom with equal parts of sap green, burnt sienna, and white. This will show through your subsequent layers and add depth to the water's surface.

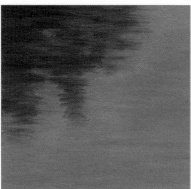

STEP THREE Now that your underpainting is finished, create the whitish reflection of the top surface of the water. Mix a milky semi-glaze with three to four parts white and one part ultramarine blue and alizarin crimson. Use a soft ½-inch flat brush to apply a layer over the entire section of water to the right of the tree reflections. You can use a small amount of this color over the tree reflections to soften them if needed. Before the paint gets tacky, use a very soft, dry blending brush to remove all brushmarks.

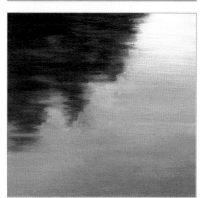

STEP FOUR Once your previous layers dry completely, create a strong sense of atmospheric perspective and enhance the glassy quality of the water. Use a ¼-inch flat brush to add a layer of white with horizontal strokes, making it thicker and lighter in the distance and thinner and more transparent in the near foreground.

Rippled Lake

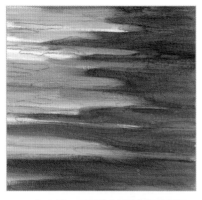

STEP ONE When painting rippled water, the reflections from the surrounding environment—such as boats, swimmers, or trees along the water's edge—merge with the cooler whites and blues of the water itself. It is important to study the curving weblike patterns created by rippling water. Start by laying in the transparent greens of the reflections using a thin mix of sap green warmed with a touch of burnt sienna. Using a ¼-inch flat brush, work from top to bottom to create a subtle zigzag pattern. Before this dries, knock down any hard edges by sweeping over your strokes with a soft, dry brush.

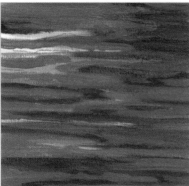

STEP TWO Once the underpainting is dry, paint your darkest blues using two parts white, one part ultramarine blue, and a small amount of sap green. Thin the paint so it flows smoothly. Use the same zigzag method to suggest horizontal ripples that are thinnest in the distance and fattest near the viewer.

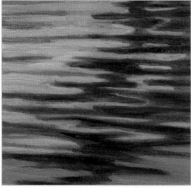

STEP THREE To paint the lighter, bluish white reflections on the water's surface, mix white with small amounts of ultramarine blue. Use a #4 flat brush (or smaller round brush) to carefully paint horizontal bands that end gradually in the dark shadows of the water. Then apply more of the dark glaze over the shadows to blend and soften the edges of the lighter colors as you trace between them.

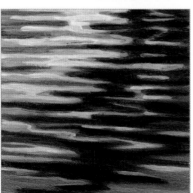

STEP FOUR Once your paint dries, add the final white highlights on the highest ridges of the ripples. Use a #2 round brush and pure white to add soft, horizontal bands wherever needed.

92 **Bubbles**

STEP ONE The key to painting bubbles is to create the illusion of transparency. Lay in your background colors and blend them so they are soft and nondescript—and you will have already done half the work! Use any color combinations, depending on where your bubbles are, and pounce to smooth out all the brushstrokes, leaving subtle gradations of color to build upon. For this background, apply a thin underpainting of sap green.

STEP TWO With the background in place, define some of the bubble edges with semi-transparent layers of the colors you wish to reflect. Begin with a blue-gray mix of ultramarine, white, and black. With a ¼-inch flat brush, start at the edges of your bubbles and, as the paint diminishes on your brush, blend the color toward the center of the bubble. Avoid covering the entire background to create a sense of transparency.

STEP THREE Once your previous colors dry, create a thin, semi-transparent mix of white and a small amount of phthalo blue. Use a #2 round brush to add the brighter lights circling each bubble. If the marks are too harsh, use your finger or a dry ¼-inch flat brush to blend the inner edge toward the centers of the bubbles. Add a few smaller solid circles; then gently press your finger into their centers to lift some color and make them appear transparent.

STEP FOUR To finish, add bright colors along some of the edges of your bubbles, along with a few highlights with white to give them a more reflective appearance. Integrate the bubbles with the background by adding some bright green highlights using a #2 round brush.

Smoke

STEP ONE Work from dark to light and keep your edges very soft to achieve the curving, intricate patterns made by smoke as it follows the air current. Start the dark background with a thinned mixture of equal parts of Payne's gray, alizarin crimson, and ultramarine blue. Thin this mix and use a ½-inch flat brush to stroke in the curves and soft edges of the smoke, retracing your marks until they are blurred sufficiently.

STEP TWO Now focus on creating the more subtle gradations within the background by working wet-into-wet with a soft ½-inch flat brush. Variations of black, white, ultramarine blue, and alizarin crimson work well to create the dark purples of smoke as seen in the dark. Retrace your strokes as many times as needed to create very smooth gradations and edges.

STEP THREE After your paint dries, add more white to your color and begin to build the lighter values of the smoke, adding interest and detail as the smoke twists and turns in the air. Keep your color semi-transparent by thinning it and then blending it with a soft, dry brush. This will soften your edges and eliminate brushmarks.

STEP FOUR Once the previous layers dry completely, add the brightest whites to represent where the smoke is thickest and where the light hits it most directly. Use a #2 round brush to dab in the white, and then use a soft, dry blending brush to eliminate the brushstrokes.

94 Ocean

STEP ONE Ocean water features a variety of textures, from thick sea foam swirling along the surface to fine spray shooting off the tops of waves. With a little experimentation, you can learn to create realistic textures that do not appear too contrived. The more relaxed you are with the handling of your brush, the easier these textures will be to create. Start by building the transparent blues of the water using thinned manganese blue hue and ultramarine blue with a ½-inch flat brush. Apply the paint in loose, brushy strokes that follow the contours of the water.

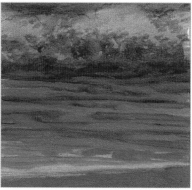

STEP TWO To hint at the sand colors under the shallow layers of water, mix equal parts of yellow ochre, Venetian red, and white cooled by a touch of ultramarine blue. Use the tip of a ½-inch flat brush to loosely paint bands of color along the shore. Next use the same method to add darker bands of blue glaze mixed from equal parts of ultramarine blue and manganese blue hue. Work wet-into-wet, blending the areas of color together as you to create soft transitions within the water.

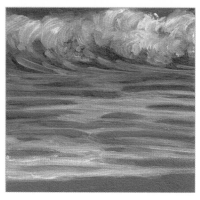

STEP THREE Having established the darker colors under the surface and in the shadows, it's time to add the lighter whites of the foam. For the waves, use a ¼-inch flat brush loaded with a mix of white and a touch of phthalo blue. Work from the back of the wave to the front and follow the flow of the water. Then thin the paint and switch to a #2 round brush to paint the soft pattern of foam as it rolls up onto the sand.

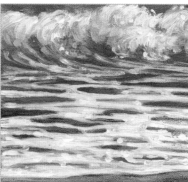

STEP FOUR Once your previous layer dries, enhance the brightest whites of the foam in the foreground and within the waves. Load a #2 round brush with white paint thinned for flow, and hold your brush by the end of the handle to loosely add opaque white strokes that add dimension to the foam.

Clouds

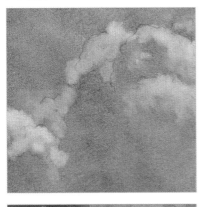

STEP ONE To create the fluffy white clouds you would find in a Maxfield Parrish painting, use a ½-inch flat brush to apply a warm gray underpainting with a mixture of three parts ultramarine blue, one part yellow ochre, and one part white. Use the pounce technique to remove the brushstrokes, and use a soft, clean cloth to pick out color where the light is strongest on the clouds. Keep your edges soft and blurred like clouds in nature.

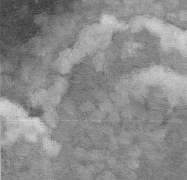

STEP TWO Various shades of ultramarine blue mixed with white are perfect for the fluffy, cool cloud shadows and for the soft edges that blend into the sky. Use a ¼-inch flat brush and short, impressionistic strokes to start building texture in these areas. Avoid covering all of your underpainting, as its warmth will add depth and variation to your clouds.

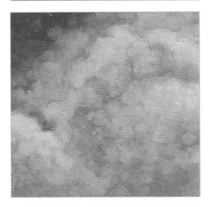

STEP THREE After your paint dries, fill in the parts of the clouds that are receiving the most light. Use white warmed with a small amount of yellow ochre for the tops, and use white darkened with a bit of ultramarine blue to enhance the details in the shadows or in the distance.

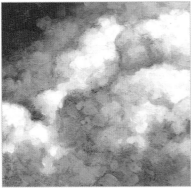

STEP FOUR Once your base dries, add a final layer of pure white on the areas where the light is strongest. Keep your transitions soft, but build up the thickness of your paint in your focal areas and where the light is brightest. Remember that thick paint tends to come forward, whereas thin, transparent color tends to recede.

96 Raindrops on a Window

STEP ONE Before you can paint fog and raindrops on a window, begin with a background color you can build on. In this case, use a blue-gray mixed from manganese blue hue, ultramarine blue, and a small amount of white. Apply the paint using a ½-inch flat brush or larger, depending on your surface area. Pounce out all the brushmarks to leave a smooth gradation of color.

STEP TWO After the base colors dry, use a ¼-inch flat brush to scumble white thinly onto the surface of your board, simulating fog or steam on the window. Your base layer should show through but appear blurred. While the scumbling is wet, load a #4 round brush with a very thin version of your background color and press it at points along the top of your painting, letting the liquid drip down your surface. Some of the wet paint beneath should float up and gather in the drips. You can also gently drop bits of thinned color into these drips until you achieve the desired effect.

STEP THREE Continue building texture across the window by scumbling with a ¼-inch flat brush and a bluish white mix, working around the main streaks. A little stippling with the corner of your brush will look like condensation collecting on the glass.

STEP FOUR Now add the final streaks of rain on the window. Hold your support vertically as the thin paint drips down your surface.

Raindrops from the Sky

STEP ONE While painting raindrops, focus on building depth through the subtle contrasts between hard and soft edges. The first layer will be the softest (or blurriest), as if the rain is falling in the distance. To achieve this effect, create thin mixes with varying amounts of sap green and black, lightened with white. Using the edge of a ½-inch flat brush, turn your support so you can stroke from side to side in long stripes of various widths. Blur your brush-marks by tracing over them with repetitive strokes.

STEP TWO Once your previous layer dries, define the vertical lines created by falling rain. Turn your painting horizontally so you can more comfortably render straight lines. Use a #2 round brush loaded with a thin mix of white and a small amount of sap green.

STEP THREE To get the whites of the rain to glow, build up the thickness of the paint. Mix a very small amount of green gold with white and use the straight edge of a palette knife to place (or stamp) straight lines of color onto your image. If any line is too thick or messy, use a long striper brush to trace along the edge and pull paint upward, straightening and softening the mark as you move along its edge. Wipe your brush clean often so it readily picks up paint.

STEP FOUR To create the impression of a sunny shower, make your whites very bright. Continue using your palette knife to build the thick white paint in areas where the light is strongest. After adding another series of vertical strips of color, refine them with a wet striper brush. (If using oils, wet the brush with medium; if using acrylics, wet the brush with water.) Continue to straighten your lines by pulling out color with the brush and wiping off the paint on a soft cloth.

98 Snowflakes

STEP ONE To paint snow falling from the sky, first paint the background. In this case, create the illusion of snow at night as seen in the rays of a streetlight or perhaps in the headlights of a car. Start with a dark purple-gray by mixing equal parts of black, ultramarine blue, and alizarin crimson, lightened with a touch of white where the sky is lighter between the trees. Use the tip of a ¼-inch flat brush to dab on small dots of color with very soft, blurred edges.

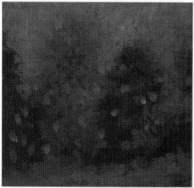

STEP TWO Using the corner of the same ¼-inch brush, continue to build up lighter and lighter layers of texture between the trees and in front of them using a various mixtures of white, Payne's gray, and alizarin crimson. Small, stippled marks work best for falling snow.

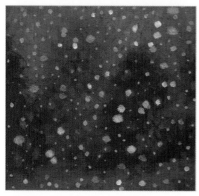

STEP THREE With the night scene background in place, you will now need to build a few layers of snowflakes. Add more white to your gray mixture and use a small #2 round brush to dab tiny spots randomly over the entire image. Use pure white for the closer and larger flakes.

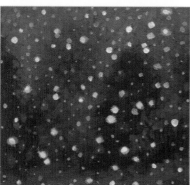

STEP FOUR For the final touches, use a fine #2 round brush to dab thick spots of pure white over the largest and closest snowflakes.

99 Snow Powder

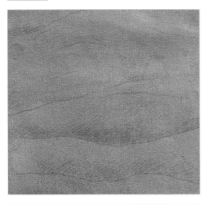

STEP ONE To establish the cool purple-grays of the shadows, mix various amounts of ultramarine blue with alizarin crimson, lightened with a small amount of white and thinned for flow. Quickly lay in an even layer of color, pounce out the brushstrokes, and pick out some color from the mounds of snow that will receive the strongest light.

STEP TWO To begin building the texture of the snow, work from the shadows toward the light, gradually shifting from darker, cooler variations of white to warmer, lighter tints. For the purple found in the shadows, mix small amounts of alizarin crimson and ultramarine blue with white. Use the corner of a ¼-inch flat brush to dab spots of color over the underpainting. Do not cover everything; the darker bits of underpainting serve as the shadows between clumps of snow.

STEP THREE After your paint dries, start building the lighter values of the snow using pure white. Start at the ridges of each section and, as the paint diminishes on your brush, scumble color into the shadows to add detail and brighten where needed.

STEP FOUR After your paint dries, add another layer of pure white along the ridges and down the sides of the snow mounds using short, round strokes. Use thicker paint in the foreground, where the added texture will read as detail, and use softer strokes as you move to the more distant surfaces.

100 Frozen Pond

STEP ONE Usually shallow ponds start to freeze over in late fall, right after the leaves have fallen from the trees. Often you can see colorful foliage through the thin layers of ice. Therefore, before you start to paint the ice, first establish the colors of the water and foliage. Use a ½-inch flat brush to block in various mixtures of burnt sienna, yellow ochre, sap green, and ultramarine blue. Work from the warmer colors, seen through the smoothest, thinnest ice, toward the cooler, bluer areas where the ice is thicker and more opaque.

STEP TWO Continue building up the colors of the underpainting. Add more blue and white to your mixtures as you move forward in your picture plane (toward the viewer), where you see fewer reflections more texture. Work wet-into-wet with your ½-inch flat brush to keep your edges blended.

STEP THREE With your underpainting complete, add the semi-transparent ice on top. Mix equal parts of ultramarine blue and white, and thin it to create a semi-glaze. Using the tip of a ¼-inch flat brush, create the diagonal lines and striations that form when shallow water freezes over. Start with the primary lines and then fill in the secondary lines to form a complex series of sections that intersect each other, forming a rippled pattern across the ice.

STEP FOUR The last five percent of work spent on a painting is what makes it come to life. A few well-placed highlights can make all the difference, giving it a sense of place and time through the quality of light. Light glimmers and glints off the surface of ice with diamondlike brilliance, but it is softer and subtler in other areas where it is absorbed by snow or seen through the atmosphere. Use white to apply these final highlights, and stroke in the direction the light falls on the ice—in this case, down and to the left.

Fall Foliage

STEP ONE You can achieve the colorful texture of fall foliage, as seen from a distance, by applying multiple layers of color. You can use a number of tools for the layering process, but sponges are particularly useful. Begin by painting the background sky using equal parts of white and ultramarine blue with a ½-inch flat brush. Let this dry before starting the next layer.

STEP TWO Before you begin isolating specific areas of foliage or individual leaves, first quickly allude to the more distant foliage that will peek through the detailed areas and add depth to your landscape. Wet a natural sea sponge and, after wringing out as much water as possible, dab it into a glaze mixed from Venetian red and ultramarine blue. Dab this onto your support, creating as much density as you desire. Remember to allow the blue of your sky to show through in areas.

STEP THREE Now that your darkest, coolest red foliage is done and dry, use the same sponge to add a warmer, lighter layer of leaves with a mixture of equal parts of cadmium yellow and cadmium orange, darkened with small amounts of alizarin crimson. Avoid covering all of the previous layers, as they will add depth to your final painting.

STEP FOUR To increase the depth of your foliage, continue using the same sponge to add a final layer of brighter leaves. The dryer the sponge and the more paint it holds, the more dramatic your additions will be. A mixture of equal parts of yellow ochre and cadmium orange works well for the top layers, where the light is strongest and the leaves are brightest.

ARTIST'S GALLERY

Elephant
See page 33

Rippled Lake
See page 113

Smooth Wood
See page 78

Smooth Rock
See page 107

Clouds
See page 117

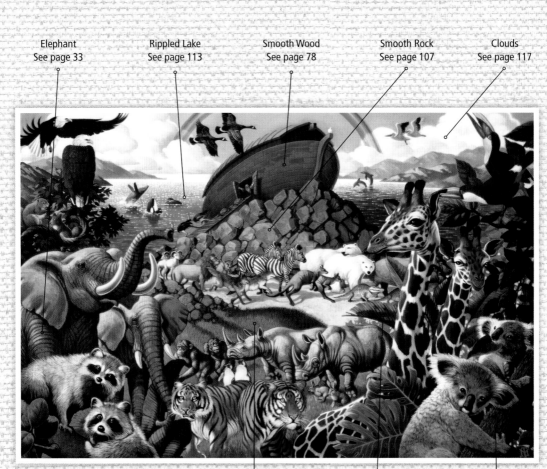

Noah's Ark, by Mia Tavonatti,
36"(w) x 24"(h), oil on illustration board.

Grass Field
See page 104

Palm Frond
See page 100

Tree Bark
See page 97

Smooth Skin
See page 17

Wavy Hair
See page 21

Polished Sterling Silver
See page 65

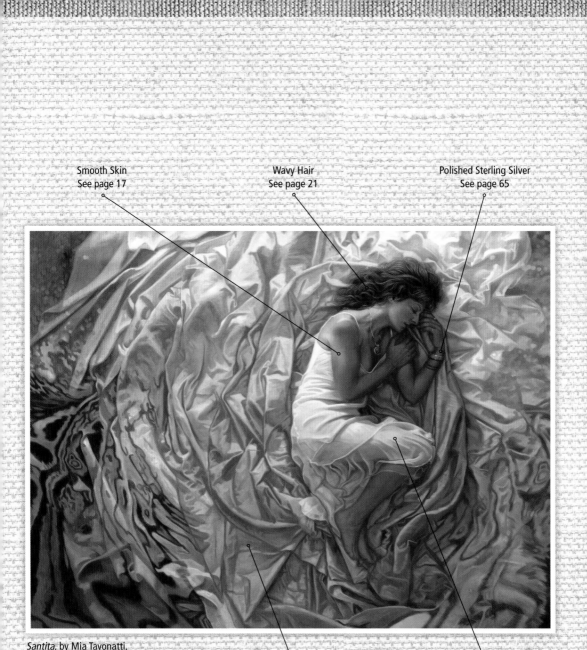

Santita, by Mia Tavonatti,
53" (w) x 41" (h), oil on canvas.

Satin
See page 50

Silk
See page 49

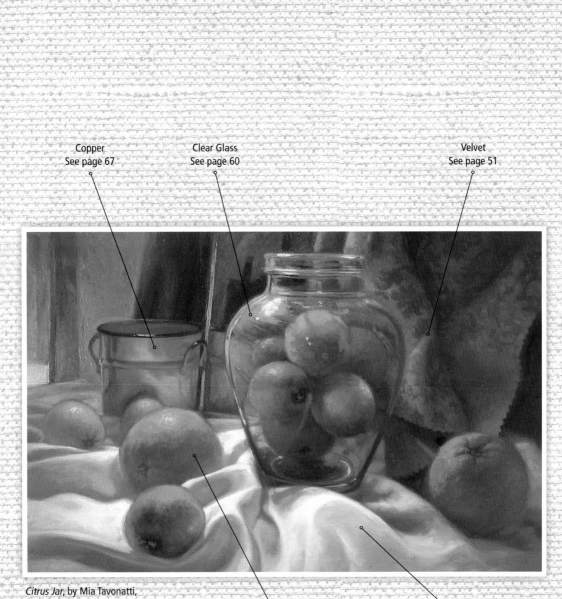

Copper
See page 67

Clear Glass
See page 60

Velvet
See page 51

Citrus Jar, by Mia Tavonatti,
16" (w) x 12" (h), oil on canvas.

Citrus Fruit Rind
See page 83

Cotton
See page 48

About the Artist

California-based artist Mia Tavonatti has been creating art professionally for more than 20 years. She earned her BFA and MFA from California State University, Long Beach, where she majored in illustration, and has studied in Paris at the Sorbonne, Parsons School of Design, and in Italy and Greece with numerous international painters. Mia has illustrated more than 20 books, eight of which she authored, as well as dozens of book covers for a variety of publishers, including Walter Foster, Harcourt Brace, Simon & Schuster, and Troll Associates.

In 2007, Mia unveiled her humanitarian project, *Svelata*, a monumental series of oil paintings on canvas at the ancient *Museo Arsenale* in Amalfi, Italy. Upon her return to California, Mia formed the Svelata Foundation and is currently producing the "Power of Words Project," a national humanitarian mural campaign.

Mia's work can be found in numerous public, private, institutional, and corporate collections, including those of Marriott Resorts and Harrah's Casinos, as well as the permanent collection of the U.S. Air Force. Her corporate clients include Lysol, Toyota, Tomy Toys, Seagram's, Martha Stewart, and Bravo/NBC. A Santa Ana resident, Mia has taught painting at Laguna College of Art & Design in Laguna Beach, California, for 19 years.